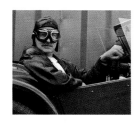

TONING AND
HANDCOLORING
PHOTOGRAPHS

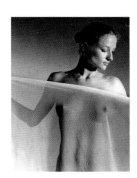

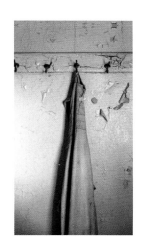

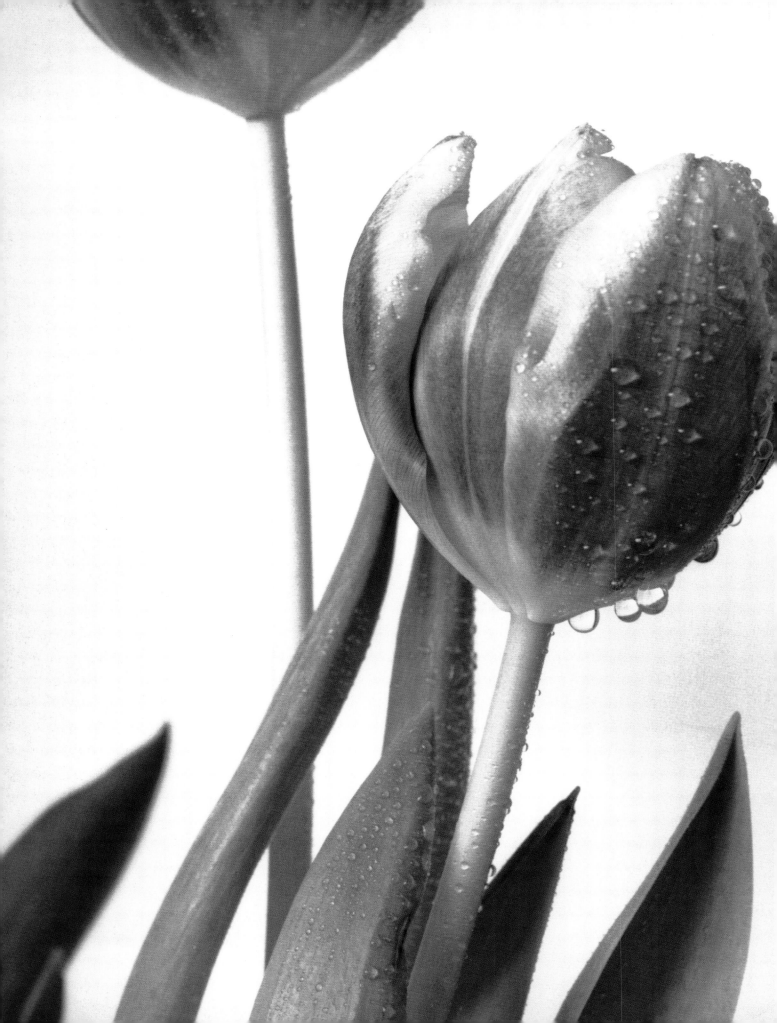

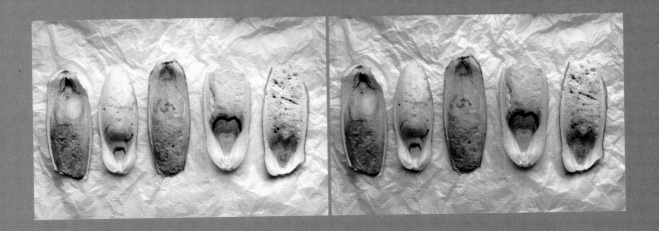

TONING AND HANDCOLORING PHOTOGRAPHS

TONY WOROBIEC

AMPHOTO BOOKS
An imprint of Watson-Guptill Publications
New York

To my parents, Winnie and Mietek,
and to my wife, Eva.

First published in the USA in 2002 by
Amphoto Books
An imprint of Watson-Guptill Publications,
770 Broadway,
New York, NY 10003

First published in the UK in 2002 by
Collins and Brown Limited,
64 Brewery Road,
London N7 9NT

A member of the Chrysalis Group plc

The right of Tony Worobiec to be identified as the author of
this work has been asserted by him in accordance with the
Copyright, Designs and Patents Act, 1988.

Copyright © Collins & Brown Limited 2002
Photographs copyright © Tony Worobiec 2002

1 3 5 7 9 8 6 4 2

Library of Congress Control Number: 2001094957

ISBN 0-8174-6062-4

Publisher: Roger Bristow
Photography by Tony Worobiec
Commissioned by Sarah Hoggett
Project managed by Emma Baxter
Art direction by Anne-Marie Bulat
Designed by Roger Hammond
Copy-edited by Chris George

Manufactured in Hong Kong

Contents

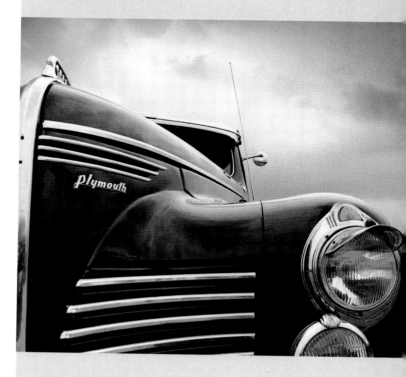

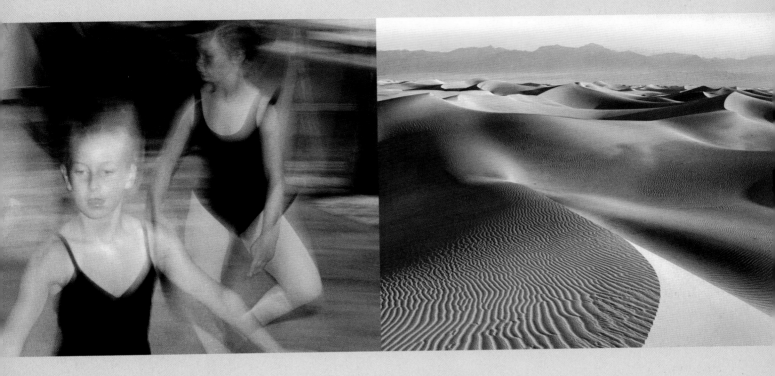

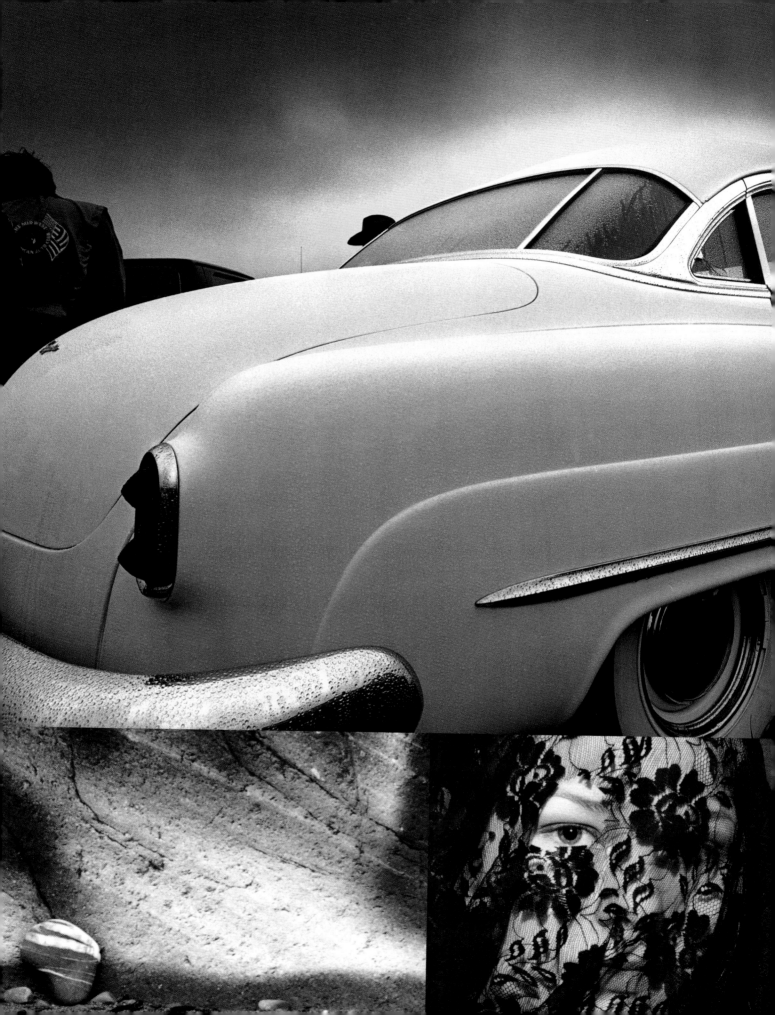

Introduction

SOME PHOTOGRAPHERS AVOID toning and handtinting because they consider themselves to be unartistic, but anyone who shows a concern for, and sensitivity to the visual world is artistic. This book offers you a vehicle to express your artistic side in the huge variety of toning and handtinting techniques.

Toning and Handcoloring Photographs starts with some simple clear-cut toning practices that are virtually guaranteed to work, progressing to some lesser known processes that are also relatively easy to do but can transform a print into a stunningly beautiful image. As you gain confidence, you can try dual toning, and experiment with many exquisite tinting techniques.

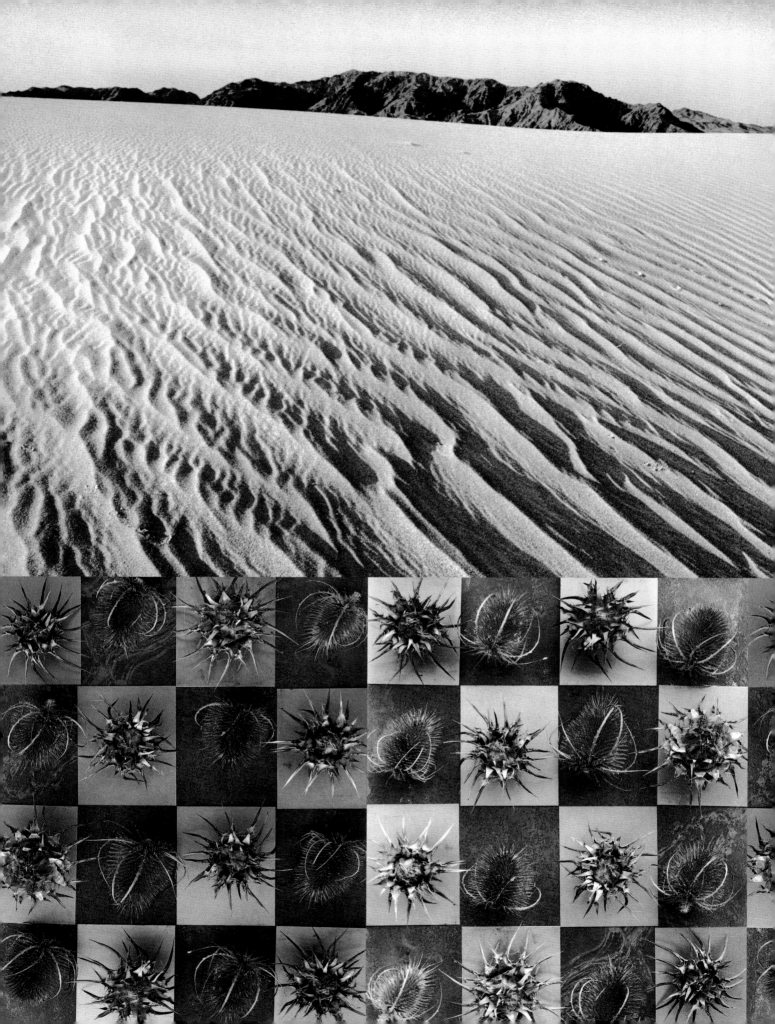

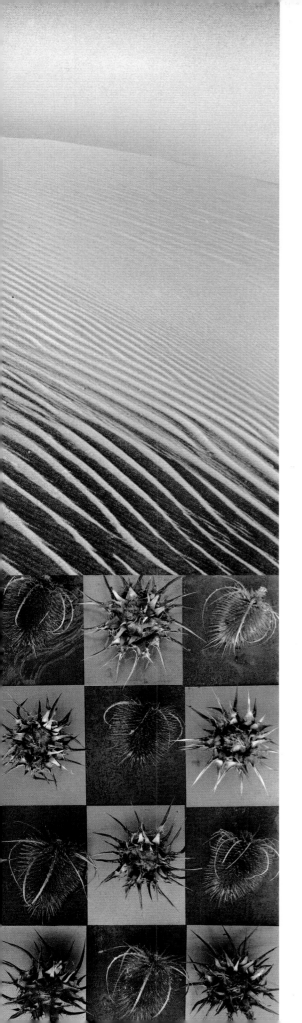

Developing a personal style is the goal of many photographers, and toning and handtinting your work is one way of achieving this. There is a vast range of toners available, and how you choose to use them will carry your own personal stamp. The secret is to find techniques that best complement the photographs you take, and then develop your own unique way of using them. When handtinting, you can start from a toned or an untoned base; you can apply your medium loosely, or in a highly controlled manner; you may wish to use just one medium, or several, applying your colors translucently or opaquely. The techniques offer enormous scope and are favored by many advertising photographers, graphic designers, and serious amateurs.

Pre-visualising your work is the key to success. The final tonality of the print is an important consideration, so avoid the temptation of using rejected prints, even at the learning stage, otherwise you will not fully appreciate what can be achieved.

The intention of this book is to give you a taste of what can be done when starting with a simple black-and-white print. The techniques and processes explained here are extremely flexible, encouraging you to work in an open and innovative way in the pursuit of your own unique style. Enjoy!

Previous page, clockwise from top left: **Car show** (see p. 121), **Butte near Hanksville** (see p. 67), **Veil** (see p. 20), **Mysterious marks** (see p. 24).

This page: top, **Death Valley** (see p. 119); bottom, **Thistles and teasels**. *Thistles and teasels* shows the whole toning process: untoned print (FAR LEFT), selenium toned, but with just a very short time in the toner (CENTER). Initially the print goes a pale green but becomes increasingly blue the longer you leave it in the toner. The final image (NEAR LEFT) has been fully toned, to maximize the blue coloration.

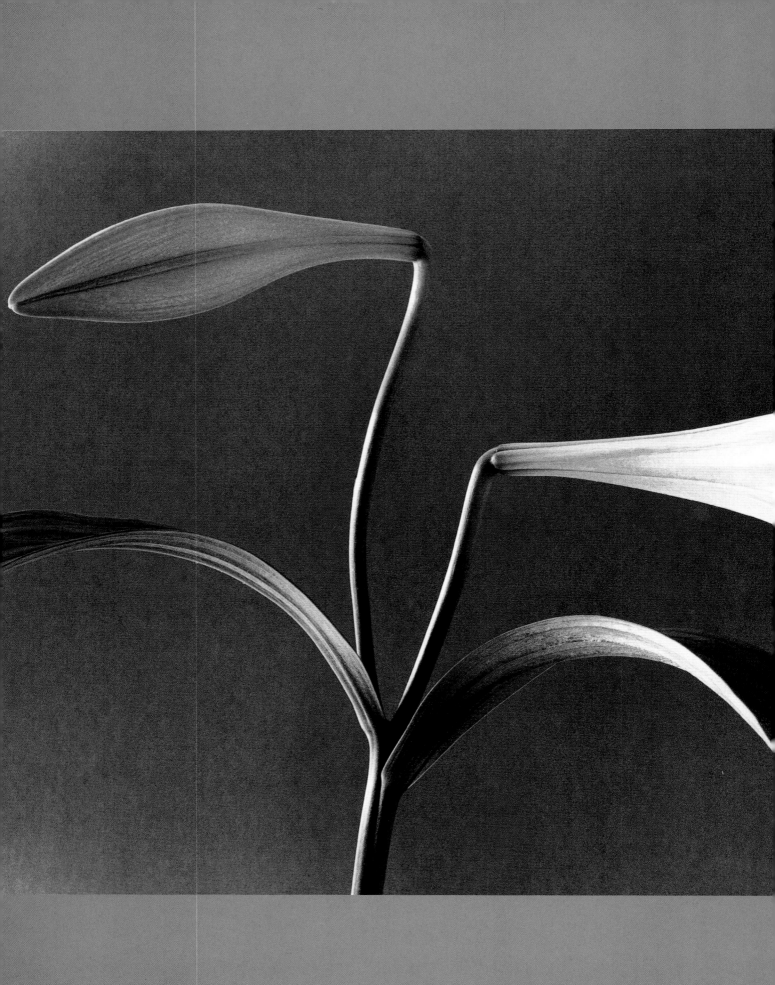

PART ONE
TONING

There are four main reasons for toning a print. Before you begin, consider why you want to tone the image and this will help guide you toward the most suitable toner.

The most obvious reason for toning is to change the color of the image to give it greater purpose and focus—and this is largely an aesthetic decision. The second is to improve the permanence of the print, so that it does not deteriorate as quickly as a normal black-and-white image. The third is to alter the contrast of your print; although most toners increase contrast, some (such as copper and porcelain blue) slightly reduce it. Finally, toning, although not essential, is often a helpful prerequisite to handtinting, as we shall discover in Part Three.

Asian lily

As a straight black-and-white print this image proved to be a little bit too contrasty. By toning it in copper more subtlety was introduced.

Introduction to toning

ALTHOUGH EVERY TONER has its own characteristics and peculiarities, there are many similarities in the way that each should be used. And if you get the basics right, then you will avoid much of the disappointment and frustration that those new to toning can face. Below are some of the essential things to remember when working with toners. They are the golden rules, if you like. Follow these carefully, and success will become so much easier to achieve.

The golden rules

1 Do not attempt to make a "silk purse out of a sow's ear." A bad image is a bad image, and no amount of tinkering with toners will alter that fact. Don't experiment with prints that you just happen to have lying around. As a teacher, I'm a great believer in the old saying "nothing succeeds like success;" to help ensure this, practice only on your best and favorite pictures.

2 Virtually all toning processes will expose any poor printing techniques or sloppy darkroom practices; if you are experiencing difficulties, carefully consider whether they could be caused by your technique.

3 Contamination is the bane of all printers who tone prints. If you can, keep individual trays specific to the various toners—or thoroughly clean them after each and every session.

4 Never handle your prints, even at the printing stage. Finger marks can remain on a print even after a wash, so always use clean tongs; if you do need to handle your prints when wet, use latex gloves.

5 Keep all your test strips; these are not just a valuable guide at the printing stage, but can prove even more useful when toning. If you are inexperienced with a particular toner, it is no bad thing to produce various test strips that can then, for instance, be toned in different strengths of toner.

6 Always use fresh fixer when printing. If you use old fixer, insoluble silver compounds will remain, which cannot be removed at the washing stage. Then, when you tone your print, these compounds show up as yellow stains, particularly in the highlights. If you use a two-bath fixing system, all the better, but take care not to overfix, as this can act as a barrier to toning. Use a non-hardening fix, or your print might resist the toning process. If you are experiencing toning difficulties, either because the print resists the toner or because of staining, it may be due to the hardener.

If you have already fixed your print in a solution with hardener, and wish to reverse this, make up a solution of sodium carbonate 1oz (30g) to 28fl oz (0.8 litre) of water, and then soak your print in this solution for 10 minutes.

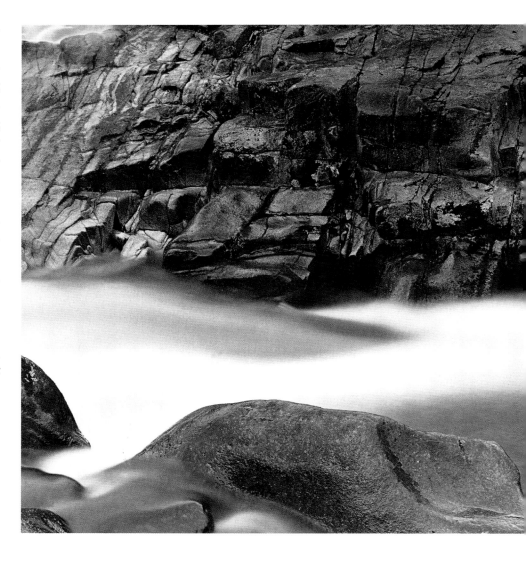

This should remove the hardening component in the fix. As always, handle your print with great care while it is wet.

7 Wash the print thoroughly according to the manufacturer's instructions. Aim to make the print as archival as possible; a thorough wash should remove all the chemical residues that could ultimately harm it.

8 Ideally, always tone your prints immediately after processing. If you have allowed your prints to dry, pre-soak them before toning so as to prevent an uneven result. Allow 2 to 3 minutes for resin-coated (RC) papers and up to 10 minutes for fiber-based (FB) papers.

9 How the toner responds to your print will be determined by various factors, the most significant of which can be the type of printing paper. Often RC papers behave quite differently from FB papers, and some toners are much better suited to one type of paper or the other. The warmth of your paper can influence the outcome of your print.

The type of developer will also have an effect, although not as dramatic as the choice of paper. The length of time you tone, and the dilution you choose to use, will also have a significant bearing. Experiment and become aware of the variations and view these as opportunities to explore further.

10 Most toners (and bleaches where required) come in a concentrated form and require diluting. Very often the mixtures recommended by the manufacturers are too strong and the reaction of the toners too quick—especially when freshly mixed. Dilute your solutions to suit your needs, allowing yourself time to judge when to remove your print. Some toners give off unpleasant and possibly dangerous fumes, so work in a light and well-ventilated space. All toning can be done in normal light.

11 Dry prints naturally—ideally in a print rack. Drying them flat can encourage pools of toner, leading to patchiness.

12 Toners can be extremely toxic and should be handled with care. Ensure mixed solutions are clearly labeled and safely stored well away from children. Never eat, drink, or smoke when using toners. Avoid contact with eyes and skin, always wear latex gloves and, if necessary, wear eye protection.

13 Allow yourself plenty of time when toning. With the more tricky techniques, you may not succeed with your first, or even with your second, print. Analyze your mistakes and adjust your practices accordingly. As the toners are used more, they often become more controllable, so have plenty of prints available. There is nothing more satisfying than getting on a roll—and always try to finish with a success.

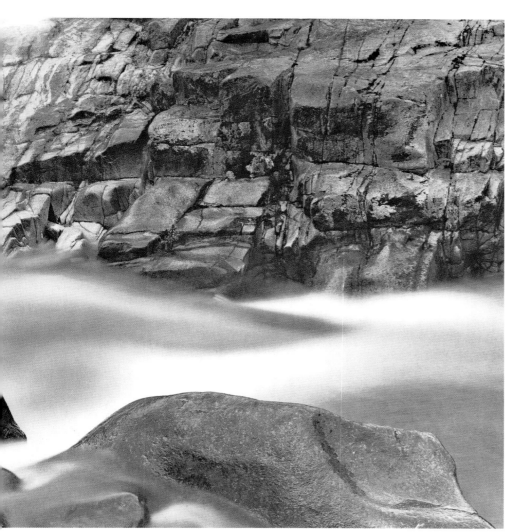

River, Glen Etive

VERSION 1: Untoned print.

VERSION 2: Slow-moving water has long had an appeal for photographers, and I am no exception. This shot was taken in the depths of winter and the toning has served to give the image a feeling of icy blue. This particular brand of toner, Porcelain blue, works particularly well on warm, chlorobromide, fiber-based papers.

Sepia toning

Sepia toning is the best known way of enhancing a black-and-white photograph; it is also an extremely flexible technique. The light brown tone, considered to be a warm, terrestrial color, makes it particularly appropriate for landscapes. Sepia closely parallels certain skin types, also making it a favorite choice for portraits. Finally, sepia toning is both a cheap and effective way of increasing your prints' archival permanence.

Abandoned interior with shafts of light
In this example, the mid tones seem to come alive. By split toning and using a lighter sepia toner, the range of the tones seem to be expanded. The yellow/sepia color of this print heightens its sense of age.

Château Fleuri
This image has been partially bleached and then toned in Fotospeed ST20 Vario Sepia Toner. The yellow/sepia color was achieved by only using 0.3fl oz (10ml) of additive per 28fl oz (0.8 litre) of prepared toner.

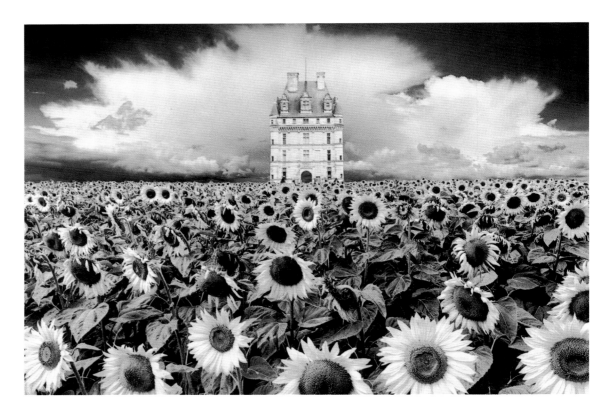

POINTS TO CONSIDER

■ Sepia toning is one of the cheapest and safest ways of increasing the archival permanence of your prints.

■ Sepia toning is a two-bath process. First you bleach your print, and after a short wash, you tone it.

■ You can have considerable control over this toner. A wide range of colors is possible—and it is easy to "split tone" images so that only the lighter areas of the print are colored.

Sepia toners generally come in two parts—a bleach and a toner. The bleach (which is generally a solution of potassium ferricyanide and potassium bromide) progressively removes the silver halides in the print, and this is then replaced by silver sulphide that produces the characteristic sepia color in the emulsion.

There are two sorts of sepia toners; the sulphide toners are traditional, but still commonly used, toners that are capable of producing very warm and rich tones. The main problem with these types of toners is that they are particularly pungent, stinking of rotten eggs.

By contrast, thiocarbamide toners are odorless, but they have other advantages as well. For me, their best feature is that they come in three parts—the bleach, the toner and the "additive." This additive is particularly useful as it allows the printer to determine the precise hue of the toner, ranging from a biscuit yellow to a full chestnut brown. Clearly this allows you a great amount of flexibility and enormous scope with regards to subject matter.

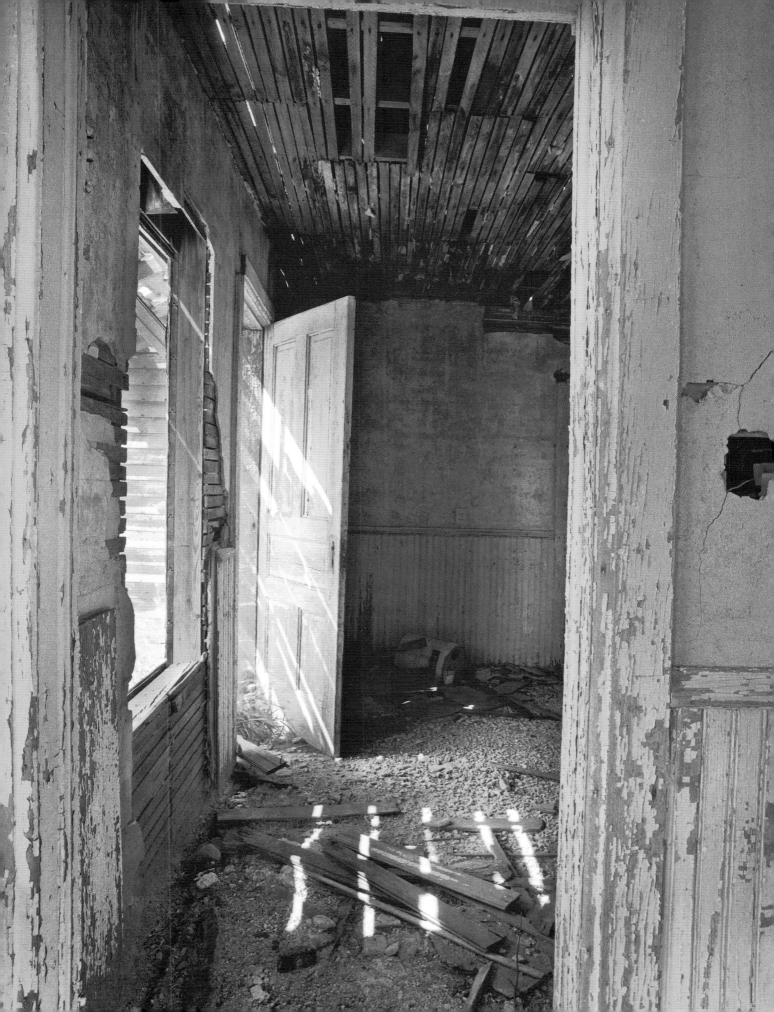

Controlling factors

1 The toning effects can be far more spectacular when using a warm-toned paper such as Ilford Multigrade Warmtone or Kodak Ektalure; sepia works well on cooler papers, such as Ilford Multigrade IV, but the results are different.

2 If you use the variable toners, then the ratio between the toner and additive can also have a significant effect, both on the tone and color. It is important that you follow the manufacturer's advice to begin with, until you have some experience of using it.

However, if you choose to use the sulphide toner, then you can ignore the manufacturer's advice and mix the toners to any strength you wish. For example, it is possible to get a very effective straw sepia color by diluting the toner by up to 90 percent of its recommended strength (although if you choose to work at this extreme, it is important to print carefully to ensure positive highlight detail, otherwise this could be lost after bleaching). You can also use the toner in a slightly more concentrated form than is suggested, in order to achieve a deep brown.

3 While manufacturers will always suggest that you bleach your print to completion, this is not always essential—and varying the degree of bleaching can become part of the creative process. Often much more interesting results can be achieved when the print is only partially bleached, so that some of the mid tones and all of the dark tones appear to have been unaffected by the toning process.

The process

Carefully slide the print into the bleach and gently rock the dish to ensure even bleaching. Keep a careful eye for changes. I generally weaken my bleach by up to 50 percent of the suggested strength in order to control the process more accurately. As the bleach ages with use, it tends to slow down—which also has the effect of making it easier to use. Once your print has reached the critical stage, remove it from the bleach and wash it thoroughly, until all the yellow staining has disappeared. RC papers require 2 or 3 minutes, while FB papers require at least 10.

Place the print in the toner. Do not remove it too early, otherwise the toning will be uneven. The longer the print remains in the toner, the more intense the toning will become, but only up to a critical point determined by the bleaching process. Work by eye, rather than by the clock. Finally, it is important that you wash your print thoroughly after toning. RC papers

Garage interior

In order to strengthen the tones in this image, the photograph was partially bleached, and toned in a lighter solution. However, the intensity of the mid tones can be increased by leaving the print in the toner for the maximum duration.

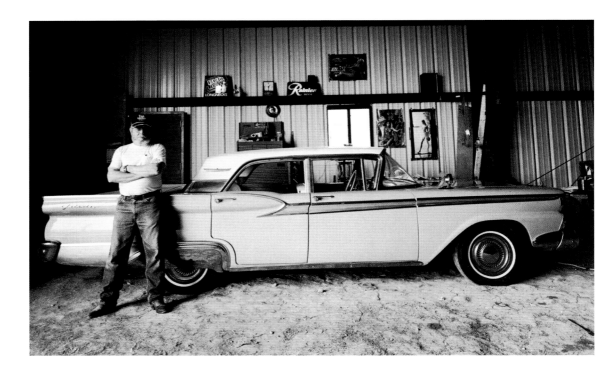

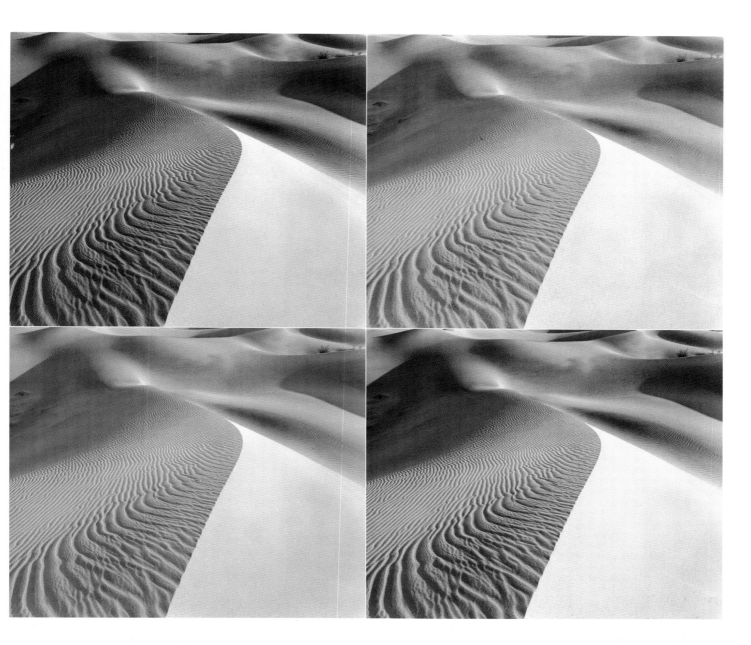

require 3 to 4 minutes wash; FB papers require at least 10 to 30 minutes, depending on the temperature of the water.

Split toning

Partial bleaching and toning, as mentioned earlier, can produce far more interesting results than completely toning your print. The toner can only convert those areas that have been completely bleached. As the bleach works faster on the lighter tones than the darker tones, you do have a fair degree of control, especially if you start with a weak solution of bleach. In effect, you have only completely toned the lighter parts of your print. This is known as split toning.

Dunes, Death Valley

VERSION 1: A straight black-and-white print. It has been printed slightly darker than normal, in the knowledge that the toning process will lighten it.

VERSION 2: The print after being bleached to completion, although it is not always possible, or even desirable to bleach the darkest areas away. It is important that you continue to agitate the bleach, otherwise the process will be patchy.

VERSION 3: This print has been toned after being bleached to completion. It is worth noting that this image is both lighter and less contrasty than the original black-and-white print. This is largely because all the tones, including the blacks, have been affected by the toning process.

VERSION 4: This final image has been only partially bleached, therefore the darkest tones have remained unaffected by the process. This is known as partial or split toning.

Viradon (brown toner)

The main characteristic of Viradon is the rich chocolate browns it can produce, especially with warm chlorobromide papers such as Ilford Multigrade Warmtone and Forte Fortezo Museum. Manufactured by Agfa, it is a polysulphide toner and is principally designed to add archival permanence to the print. It does work on RC papers but is not quite so effective.

UNLIKE SEPIA, VIRADON is a direct toner, so there is no need to bleach your print beforehand. The manufacturer's recommended dilution of the toning solution is 1:50—and if you follow this, it generally takes up to 10 minutes before the print is fully toned, even though you will see a color change after several minutes. You can dilute your Viradon toner far more, however, although you can then expect the full toning process to take even longer.

Be warned, though, that it is quite difficult to tell whether your print has been fully toned, as the color of the solution is a strong yellow, which prevents you seeing the degree of change.

Once you have judged your print to have been fully toned, you should then remove it and wash it thoroughly; the highlights are often stained yellow, but this disappears as you wash your print. Don't be alarmed if you see a milky deposit coming from your print at the earlier stages of the washing process; this is quite normal. RC papers wash very quickly; however, the yellow stain will remain in FB papers for a little longer. After the wash, occasionally there is a blooming, particularly in the blacks; don't worry, as this disappears once the print dries.

The nature of the browns that can be achieved varies; this depends on the paper you use, the dilution of the toner, and even the paper developer you use. It is impossible to suggest which is the best combination, because subject matter and personal choice are important issues; however, it is important that you experiment with a variety of papers and developers to find out what best suits you.

As with all toners, it is important that you print with Viradon in mind. Once you understand what it can achieve, you will make subtle adjustments with your printing in order to exploit its characteristics. While the density of some printing papers is very little changed by Viradon, other papers can lighten or darken. Experiment and find out what works for you.

Plymouth

Viradon can be made to work on either FB or RC paper. This image has been printed onto Ilford Multigrade RC.

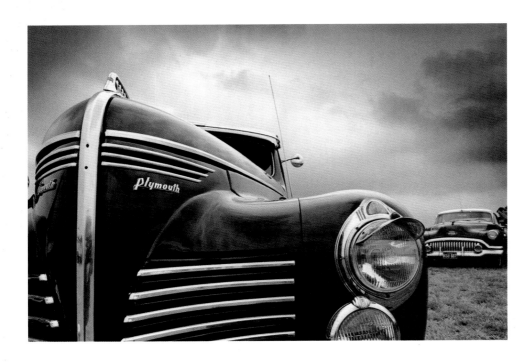

Bud Light

This image was taken while having a drink in a bar. As a straight black-and-white print, the scene appeared rather austere. But when toned in Agfa Viradon, this interior appears much warmer and much more inviting.

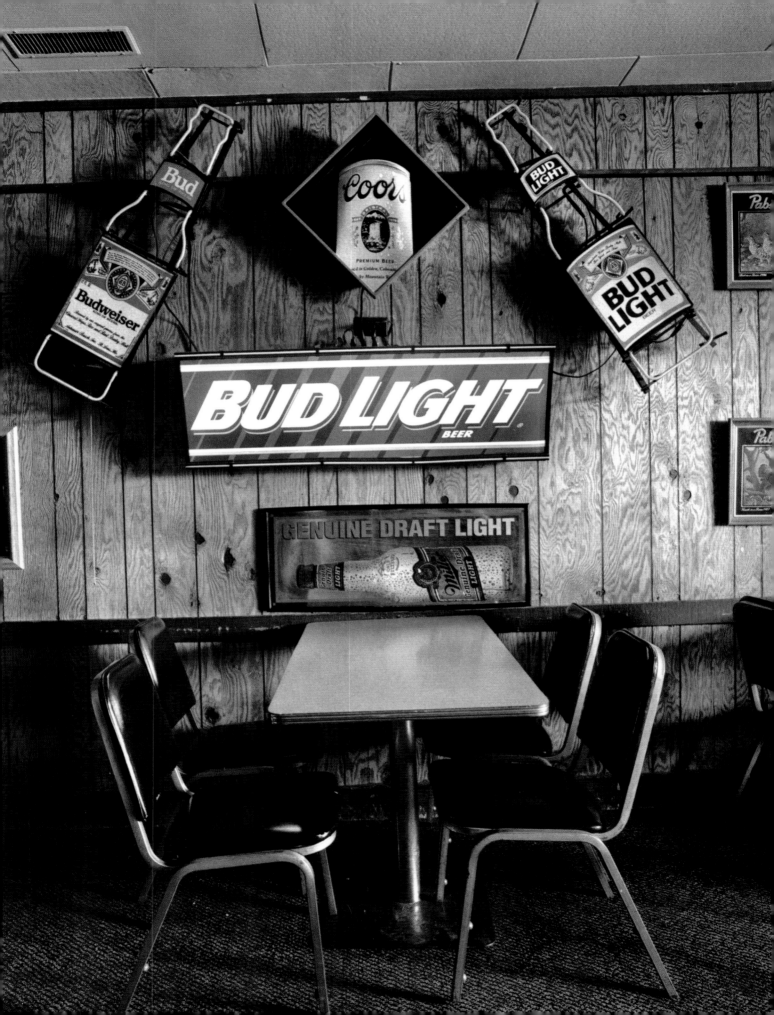

■ Viradon is an archival process and, if your print has been properly processed, should extend the life of your print.

■ The "brownness" of the Viradon is determined largely by the paper type and developer you chose to use. The richest chocolate browns are achieved with chlorobromide papers. With RC papers the effect is weaker.

■ Viradon is a single-bath toner, so there is no need to bleach.

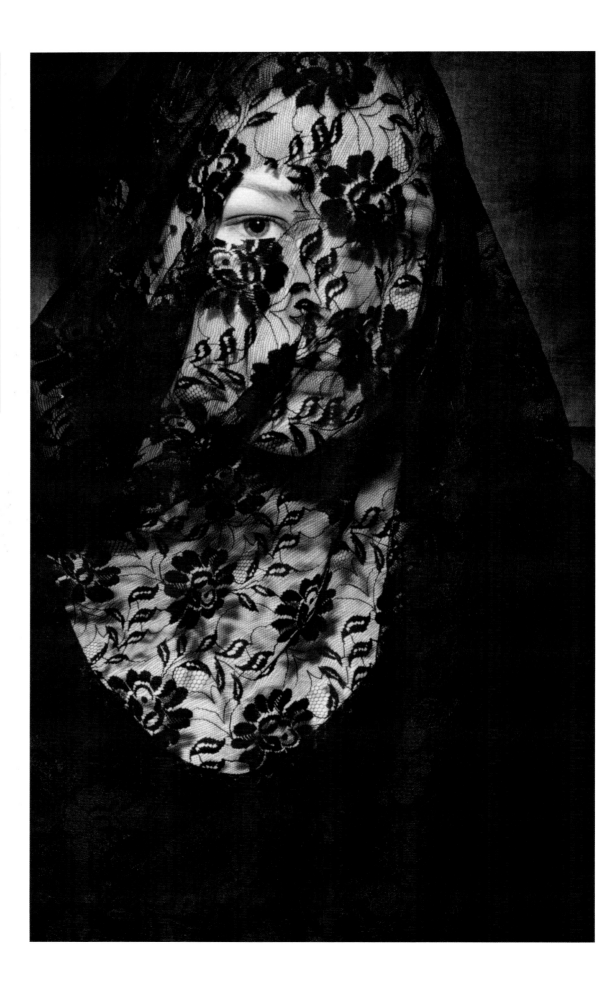

Veil

By toning this image in Viradon, a greater sense of warmth and mystery is introduced to the portrait.

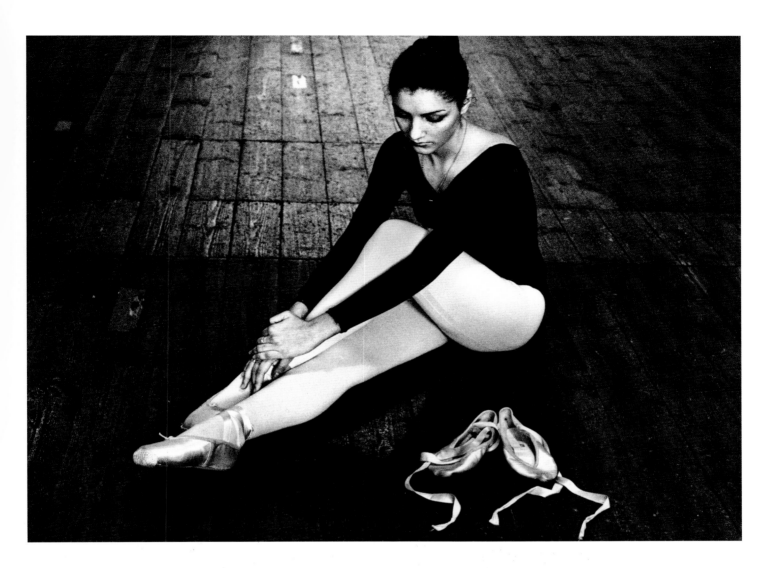

Dancer

While the figure in this print is particularly appealing, it was the rough grain of the floor that also took my eye. The rich purple/browns that characterize Viradon add a quality of solemnity to this image.

Scott looking out of window

If you dilute Viradon 1:50, you should expect to see a color change within a few minutes.

Sue

Viradon seems to work particularly well with figures. While it still remains stubbornly "monochromatic," it does introduce just a hint of warmth that complements the human form. It also seems to work well with predominantly dark, low-key images.

Selenium toning

The results from selenium toning might not appear to be particularly dramatic, but out of all the toners that are available, it is the one that I would most strongly recommend. I would even go so far as to say that if, having read this book, you decide that toning is not for you, then you must nevertheless make an exception of selenium. It truly is the "king of toners."

THE PRIMARY PURPOSE of selenium toning is to increase the archival permanence of a print. Theoretically, a well-produced black-and-white print should last for centuries; however, there are numerous polluting agents that can attack your print, and reduce its potential longevity. The selenium toner converts the silver in the print into silver selenide, which makes it far more resistant to these polluting agents and increases its archival permanence. That said, this cannot be achieved unless the print has been archivally processed in the first place.

Cool dudes

If you are prepared to tone to completion, then you are able to achieve a rich purple/brown color—as this image clearly illustrates. It was then printed onto Ilford Warm-tone FB paper.

The process

All commercially-made selenium toners come in liquid form; I would strongly advise you to

Two pebbles

VERSION 1 (ABOVE): This is a print of two found pebbles placed on a striated rocky shoreline. It was partially inspired by Japanese rock gardens. My only concern with this untoned print is that the identity of the rock is slightly lost when viewed purely in terms of black and white. VERSION 2 (RIGHT): The selenium-toned version is subtly more interesting; while the color changes with selenium are never dramatic, a sense of stone has nevertheless been created.

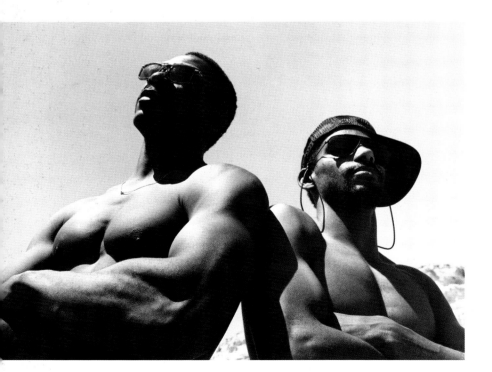

use one of these, rather than mixing your own (for reasons of health and safety that I will deal with shortly). The most widely available of these ready-prepared liquids is Kodak Professional Rapid Selenium Toner, although in recent years other manufacturers (including Paterson, Fotospeed, and Film Plus) have recognized the popularity of selenium toning by producing their own. The strength of the one-bath solution depends on what you wish to achieve.

As I have already suggested, selenium toners improve the archival quality of your print. This will be achieved irrespective of the dilution that you wish to use—providing you have toned your print for a sufficient period of time. There are two further reasons for opting to use a selenium toner.

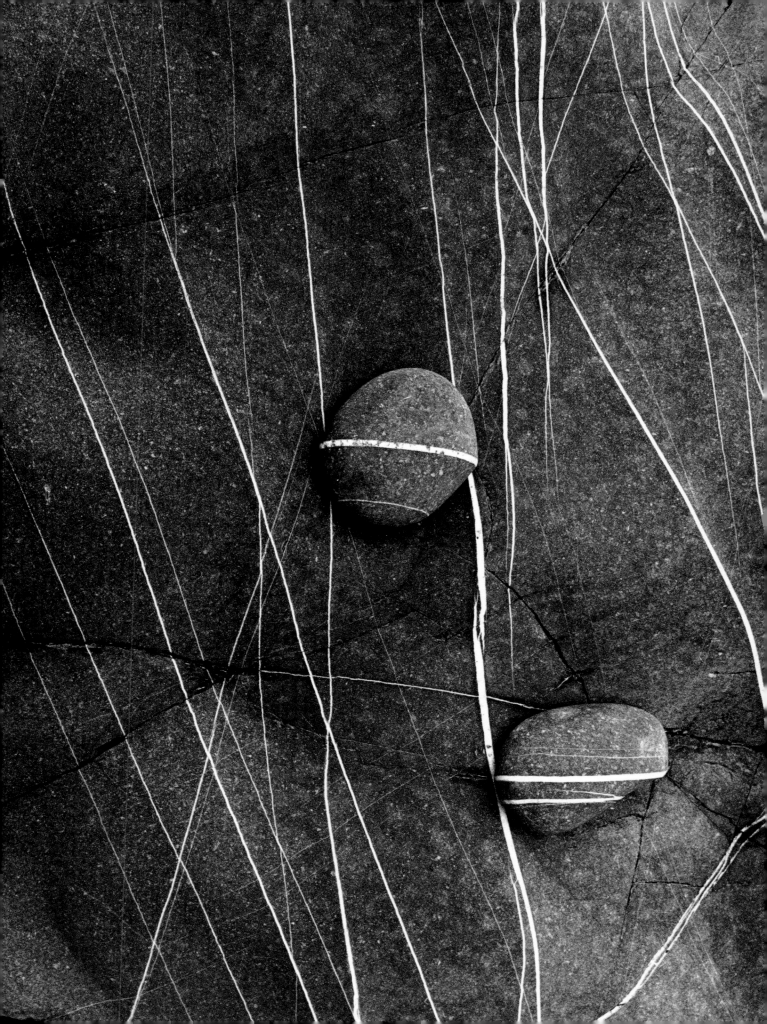

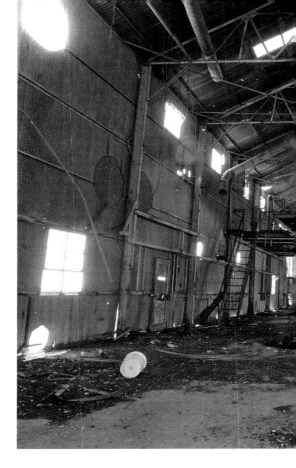

Improving D-Max with selenium

If you dilute your toner to between 20 to 40 parts water to 1 part toner, then you have a solution that increases the D-Max (print density) of your print without altering the color. This has advantages.

Often we find ourselves with negatives that need to be printed softly in order to maintain shadow detail—but when printed, the blacks appear to lack punch. By toning your print in a weakened solution of selenium, you can strengthen the darker tones without affecting the highlights. I often print just a little more softly than is normally conventional, in order to retain highlight detail, safe in the knowledge that I can then tone in selenium in order to increase the print's density.

It is important to be aware that there is an optimum point in the toning process when the maximum D-Max is achieved; if you overtone, the darkest tones will lighten very slightly. Obviously it does vary from paper to paper and by the strength of your toner, but a print can reach its optimum D-Max after only 2 minutes.

Using selenium to color your print.

If you dilute your toner to between 5 to 10 parts water to 1 part selenium, you start to notice a subtle color change in your print. Once again, this is largely determined by the type of paper you use. While you can use selenium toners on RC papers, the effects are generally far more evident on FB papers. Secondly, the warmth of the paper is very important; cooler bromochloride papers show very little color change except for a slight bias toward purple. Warm-tone papers, on the other hand, can respond quite dramatically to selenium toning, changing to a strong, rich brown; the precise color again depends on paper type.

In common with sepia toning, it is possible to partially tone your print—except with selenium, the toner affects the darkest tones first. The changes are quite visible, therefore it is easy to monitor its progress. From a purely aesthetic standpoint, I much prefer a print that has only been partially toned; a warm-toned paper that has been fully toned in selenium can look rather overpowering.

Selenium and safety

As with all goods things, there is a drawback with selenium. Much has been written about its

Mysterious marks

Toning in selenium adds interest to this shot of strange markings on a rock. Not only does the purple/brown coloration add warmth to the rock, the tonal range has also been expanded. Toning need not be very obvious to work.

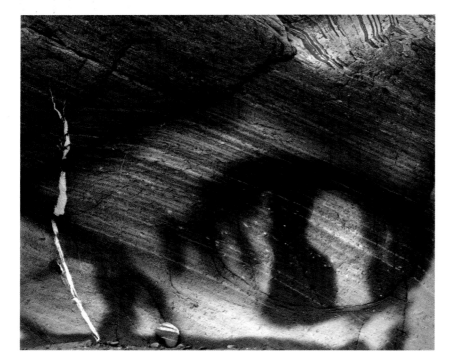

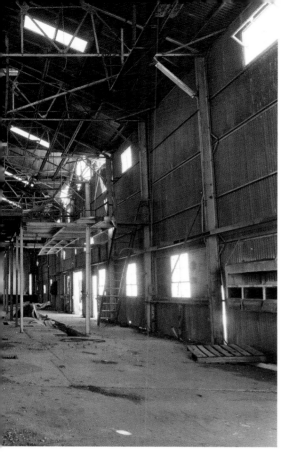

Abandoned cotton gin, Texas
This image was only partially toned in the selenium toner. Because I used a warm paper, I was clearly able to see the toner spread through the dark and mid tones. By removing the print before the selenium had time to affect the lighter tones, a much more interesting split-toned image has been achieved. The decision to use selenium was primarily an aesthetic one.

Statuesque nude
The effects of selenium toning are far more apparent on warmer, chloro-bromide papers, such as Kentmere Kentona, as used here.

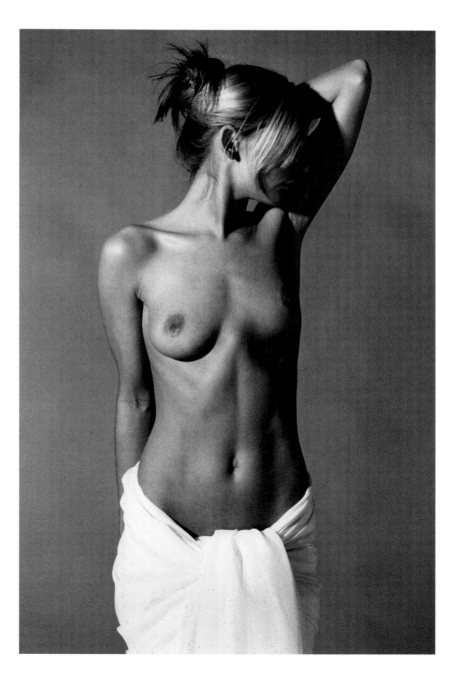

potential toxicity. Although, as ever, the research is not entirely conclusive, wherever there is even the slightest suggestion of danger to health, my own reaction is to err on the side of caution.

POINTS TO CONSIDER

■ Always wear latex gloves when using selenium. If any gets onto your skin, wash it off immediately.

■ Do not breath in the fumes from selenium solutions; always work in a well-ventilated room. If you can smell it, you are too close.

■ Avoid breathing in powdered selenium; this can often accumulate around the top of bottles that have been heavily used.

■ Even though there are formulas available for mixing your own selenium toners, avoid this, as you risk handling neat, and potentially dangerous, concentrations of selenium.

■ Selenium is a direct toner that is mainly sold to increase the lifespan of your prints.

■ Selenium is an invaluable aid to so many very beautiful split-toning processes—as we shall see later in this book.

■ Selenium can be used on its own to increase print density, strengthening dark tones without affecting the highlights.

Blue toning

Blue toners (also known as iron toners) are bought as single-bath solutions that already have bleach added. Generally, they darken the print—but they also have the perverse tendency to bleach out the lightest highlights. The best prints to use are those with a limited tonal range but with positive highlight detail. Some users find this difficult to assess. One way around the problem is to immerse your print briefly in a weak solution of sepia bleach prior to toning—although it is important to remove it before the bleach has any chance of affecting the final color. I normally bleach my print for no more than 3 or 4 seconds.

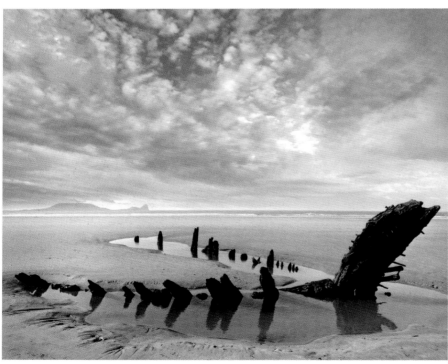

Wreck on Rhossili Beach

VERSION 1 (ABOVE): This photograph was taken on a cold January day, which the untoned version (above) does very little to convey.

VERSION 2 (RIGHT): Here I have used a very weak solution of blue toner and have not fully toned the print. In this way, I was able to achieve a pale gray/blue that is much more in keeping with the mood of the photograph.

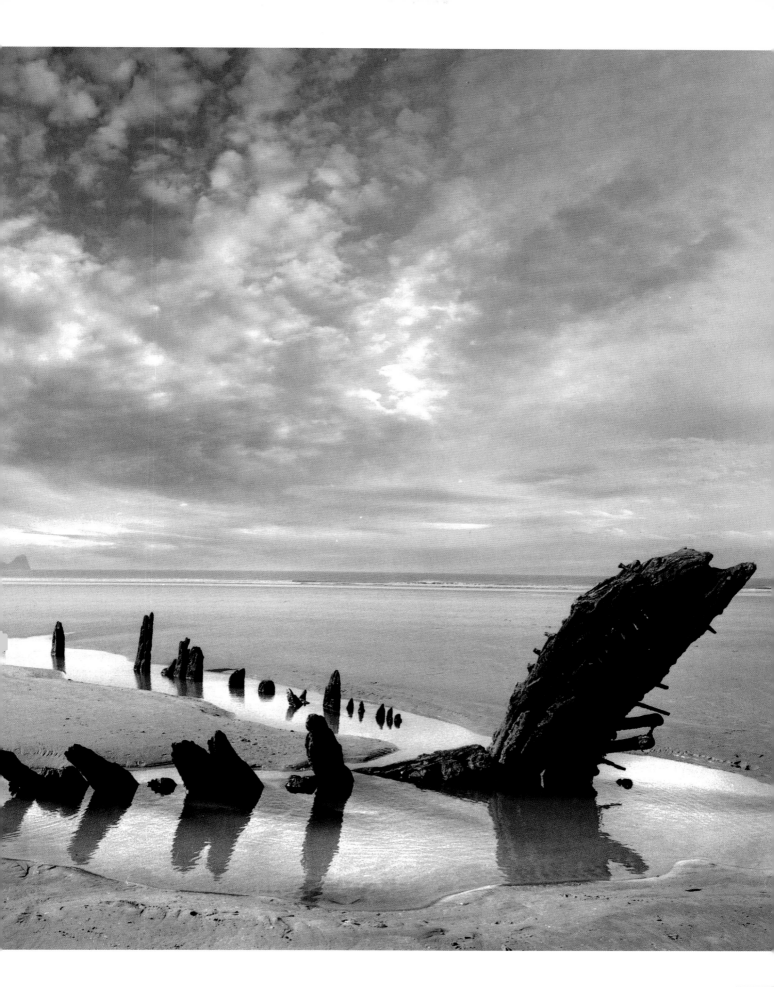

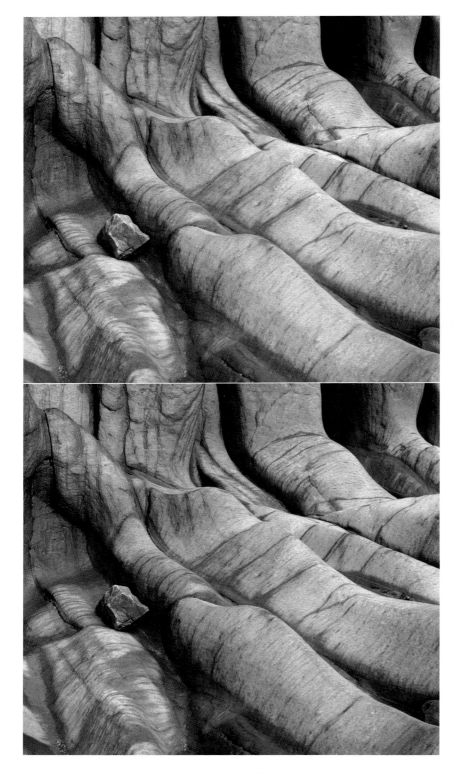

Rocks at Mortehoe

Version 1 (above): Untoned print.

Version 2 (below): In order to create this cold, stony blue version, I first toned the print blue and then put it in a much-diluted paper-developer solution. Gradually the toned print started to revert back to its original black and white, but it was removed before it had a chance to develop completely.

IN COMMON WITH all toning processes, it is important to be aware of the symbolic qualities of the color that you are using. Normally we associate blue with the sky and the ocean, but of course it occurs in a far wider range of situations. Blue is the coolest color in the spectrum, so it is suited to subject matter we commonly associate with freezing situations, such as ice and wintry weather.

It is worth noting that a wide variety of degrees of blueness can be achieved depending on how much silver you tone away, what kind of paper you choose, and whether you opt to "intensify" your blue.

Cost and availability

Blue is one of the cheapest and most readily available of toners and can be bought from most photographic stores. Blue toners are made by a number of manufacturers, including Fotospeed, Paterson, Speedibrews, Tetenal, and Colorvir. While they appear very much alike, they are subtly different, which makes them all worth experimenting with.

Unmixed, the shelf life of all blue toners is excellent, but even when mixed, it will last for several weeks and is relatively safe to use. It is, in principle, a chromogenic toner (the image is bleached before being redeveloped by the color toner). It is also a moderately flexible toner that works on either FB and RC papers, although different manufacturers aim their toners at different paper types. For example, while Colorvir appears to work better on RC papers, Speedibrews Blue Toner works far better on FB papers.

The process

Because the bleach is built into the toner, you will still need to start with a print that is 10 to 15% lighter than the result you anticipate the final print to be. Blue toners, and especially freshly mixed blue toners, are notoriously quick-acting, but you can slow down the process by diluting your toner to between 25 and 50% of the recommended strength. Also, it is worth putting through a print you do not particularly

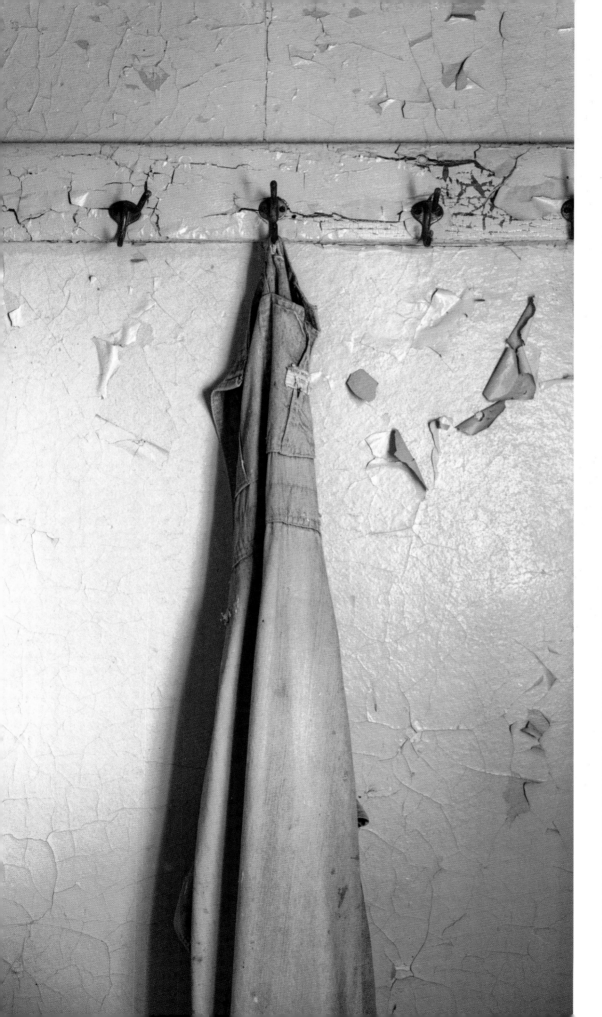

Discarded dungarees
I found these dungarees
in an abandoned farm in
North Dakota. I was keen
to recreate the denim
color so toned the image
blue. I introduced an
element of grayness by
immersing the toned print
in a very weak solution
of paper developer.

POINTS TO CONSIDER
■ Blue-toned prints
are easily marked and
should be handled
with care.
■ Blue is an excellent
toner to use in
combination with
other toners, when
split toning (as discus-
sed in Part Two).
■ Blue is an extremely
flexible toner, allowing
great variation of hue
and tone. With care,
you should be able
to achieve a blue that
accurately reflects the
intended mood of
your print.

value, in order to take the "sting" out of freshly mixed blue toner. It is very easy to overtone, creating a rather harsh blue, so keep a close eye on your print while it is in the toner. As soon as you detect even the slightest change, remove it and put it in the print washer. It is far easier to put it back in the toner for an extra few seconds if it is not toned enough than it is to remedy a print that has been excessively toned. If you do overtone, this can be corrected in one of three ways:

1 You can try washing the excess blue out. However, this can be time-consuming, and the results sometimes uneven.

2 You can try redeveloping your blue-toned print in a very weak solution of paper developer, (try 1 part developer to 50 parts water). However, you do need to act quickly, and once you detect even the slightest change, you should remove your print immediately. Then wash the print thoroughly.

3 Try putting your print in a much-weakened solution of paper fix. Try a solution of 1 part

Geyser at Yellowstone
This print was taken in the middle of the summer, but I would have preferred it if I could have photographed it in winter. By blue toning, the image is immediately more bleak and dramatic, conveying that cold chill of winter.

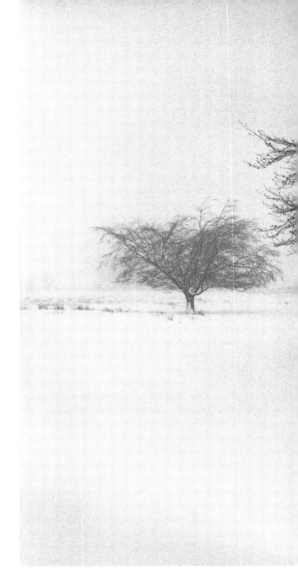

fixer to 50 parts water. The process and the results are very similar to redeveloping in paper developer. Wash the print thoroughly.

Occasionally you may have difficulty removing a yellow stain in the highlights (this seems to be a particular problem with FB papers). If this persists, put your print in a weak saline solution and then continue washing.

Intensifying the blue

You can increase the saturation of blue achieved by the toner in one of three ways:

1 Leave your print in the toner for longer than usual. You do need to appreciate that the longer you tone your print, the darker—as well as bluer—it will become.

2 Alternate the toning and redevelopment process: after toning your print, wash it, and then put it into a normal solution of paper

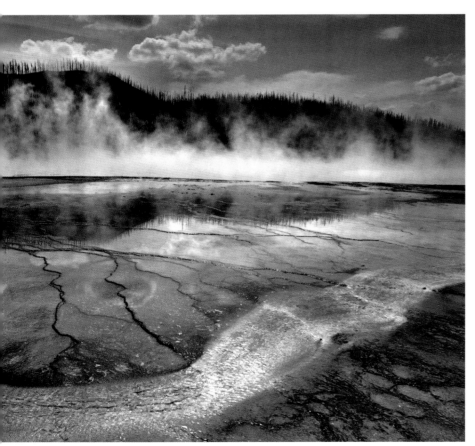

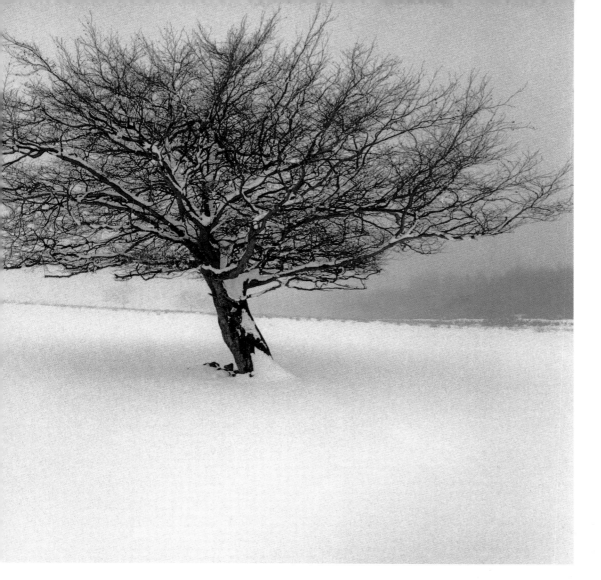

Tree in winter mist
Blue is a particularly
appropriate toner to use
for bleak, wintry scenes.
In this case I made sure
that a solution of Foto-
speed Blue Toner was
well used in order
to avoid the more vibrant
blue one normally gets
with a fresher solution.

developer. Gradually the print will revert back to its original black-and-white tones. Wash your print (there is no need to fix it), and then retone it. As your print starts to revert to blue, you will see that the intensity has greatly increased. This is a process that you can repeat again and again, until you get the intensity of blue you are after.

An interesting extension of this technique is that, once you have achieved your ultimate blue, if you then put your print into a weak solution of selenium (try 1 part selenium to 29 parts water), you can then achieve a purple tone. You must only leave it in the selenium for a very short time and be ready to remove it very quickly, otherwise this transitionary color change could be lost.

3 Blue is a chromogenic toner, and in common with other chromogenic toners, it can be intensified using potassium bromide.

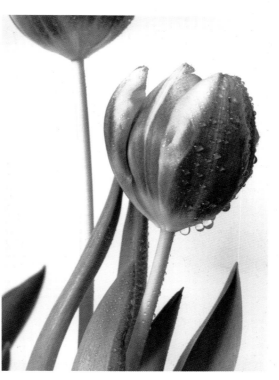

Tulip
While toning often offers
the opportunity of
replicating the colors we
naturally see in nature, it
does not always have to.
Flowers, and tulips in
particular, can be very
colorful indeed; toning
them blue makes the
image appear even more
monochromatic than it
would as a black-and-
white print.

Toning with porcelain blue

Porcelain blue toner, manufactured exclusively by Speedibrews, behaves quite differently from traditional blue toners—and brings with it several advantages. First, it requires a separate pre-toning bleach bath, that offers additional control of the technique. Second, it lightens, rather than darkens the print, so it works particularly well with low-key subjects. In fact, depending on the results you want, you may need to print between 15 and 20 percent darker than normal. Third, it does offer quite a different blue—that is much closer to cerulean blue than the conventional Prussian blue that most other blue toners achieve. Finally, and perhaps most interestingly, while tests have not been conclusive, it is claimed that porcelain blue toner offers greater archival permanence than that achieved by other, more traditional blue toners.

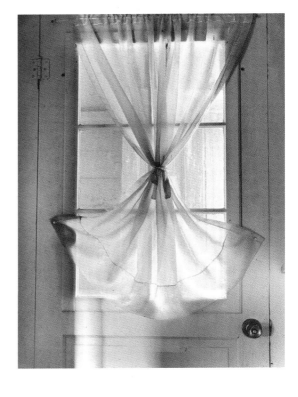

Net curtain

Porcelain blue toner works much slower than conventional blue toners, so you are in a position to remove your print from the toner at precisely the right time. When toning, your print will both lighten and intensify the longer you leave it in.

Rail carriage 1482

When I first saw this railroad carriage, I was immediately drawn to the "appeal of steel." Porcelain blue toner has a wonderful capacity to emulate quite different sorts of blue from normal blue toners, including pale, metallic blues.

THE KEY TO successful porcelain blue toning is in the bleaching. As I have already indicated, the bleach can be very aggressive, particularly when fresh, so I would start with a less-valued print to get a feel for its strength. You have a choice of either partially or completely bleaching your print; if you completely bleach it, you will remove virtually all the silver and consequently gain a much lighter image.

For most subjects, I prefer just to bleach partially, which is why using a weakened solution is so important. Take great care at this bleaching stage; initially nothing seems to be happening, and you can easily be lulled into a false sense of security. Do not necessarily wait until you can see clear evidence, because by then it could be too late. After bleaching, wash your print in running water for at least 10 minutes.

The process

Fortunately, when compared to the bleaching, this is a relatively slow process and does offer the printer a fair measure of control. It is important to immerse the print completely into the toner to ensure an even result.

Initially, your print changes to a greenish hue, but gradually the blueness emerges. The

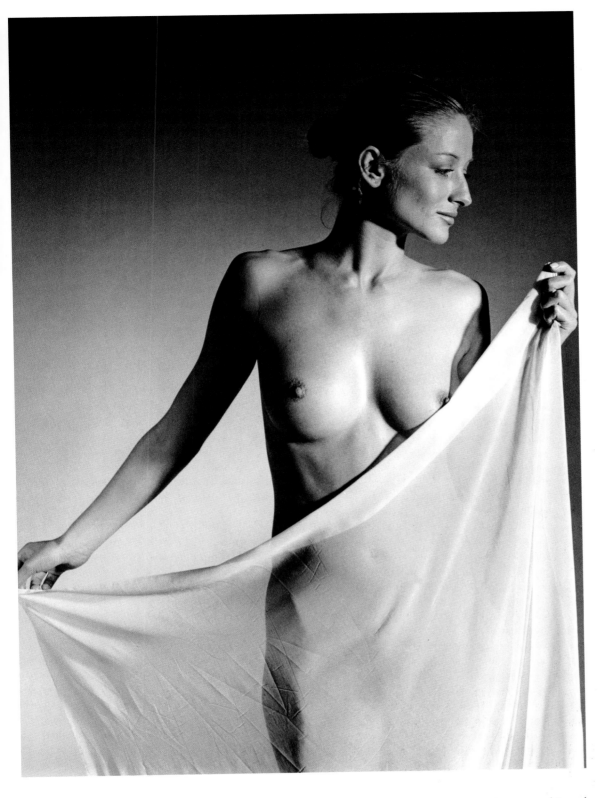

Model with light material

A frequent complaint about porcelain blue is that it bleaches out the highlights. This problem is easily resolved by ignoring the instructions and bleaching very sparingly. This has the added benefit of inducing an interesting split between the tones. The dark tones remain a deep chocolate color, and the lighter tones assume the delicate blues commonly associated with this toner.

POINTS TO CONSIDER

■ Porcelain blue lightens, not darkens, your print.

■ It is a two-bath toner, so you are required to bleach your print prior to the toning process. This offers you enormous control.

■ While in no way can this be described as an archival process, it is believed that a more permanent print can be achieved using porcelain blue, rather than a conventional blue toner.

■ You can halt the process at the bleaching stage, or at any stage during the toning process, so long as you wash the print thoroughly afterward.

color changes the longer you tone, becoming both bluer and lighter. Once you appreciate this, subjects that you thought were unsuited to conventional blue toners may work well in this one. The longer you tone in porcelain blue, the more stable the color becomes.

The most interesting results are achieved with prints that have only been partially bleached, because you are then able to maintain the full tonal range. If you do bleach to completion, then you will find that the tonal range is reduced.

Gold toning

Many experienced printers regard gold toners as highly as they do selenium ones, as they both share many of the same qualities. In particular, they are both primarily designed to improve archival permanence. Gold toner does, however, work quite differently from selenium. Whereas selenium and many other toners convert the silver into another compound, the molecules in the gold toner bond directly to the silver.

Physalis

Like selenium, gold is one of those toners that is valued for its archival rather than its aesthetic qualities, although you can achieve an interesting gray/blue, especially if you use a warm chlorobromide paper, such as Kentmere Art Classic, used here.

POINTS TO CONSIDER.

■ Gold toners are very expensive.
■ They are best used on high-quality, fiber-based papers.
■ Gold toners enhance the archival permanence of the print.
■ The blue coloration can be enhanced using warm-tone and gloss papers.

WHILE GOLD TONERS do work on RC papers, their effects are far more apparent on FB papers. When one also considers the cost of this toner, it does seem a criminal waste to use it on anything other than high-quality, fiber-based paper.

Intensifying the color

The warmth of the paper has a significant bearing. If used on a cold or neutral paper, then the toning is slight, producing a cooling effect with just a slight hint of blue. The blueness becomes far more evident when using warm-tone papers. If you use Ilford Multigrade FB Warmtone, you should be able to achieve a subtle gray/blue; with papers that are richer in chlorobromides, such as Kentmere Art Classic, the drift toward blue is even more apparent.

The blueness can be even further enhanced by using a warm-tone paper developer, such as Agfa Neutol WA.

The temperature of the toner also has a bearing; one normally uses a toner at room temperature (around 70°F/21° C), but if you heat up the solution then the toner becomes far more active; you can safely go up to 95°F (35°C) without doing any harm to the emulsion.

The degree of blueness can also be determined by whether you use matte or gloss paper; the blueness seems much more intense if you use glossy paper.

The effect of toning is accumulative—the longer you tone, the stronger the hue becomes. There is, of course, a point when the toning reaches its maximum potential, normally after 30 minutes.

Finally, you will notice that the harder the grade of paper you use, the more difficult it is to achieve a blue; use a softer grade where possible.

Available toners

The price of this toner makes it a very specialist market, and therefore there are not too many manufacturers producing it. Tetenal is probably the best known, although others have recently started to produce them, including Paterson, Film Plus, and Fotospeed.

Untitled

The effects of gold toning are visually far more apparent on warm, chlorobromide papers. This image has been printed on Fotospeed Tapestry paper.

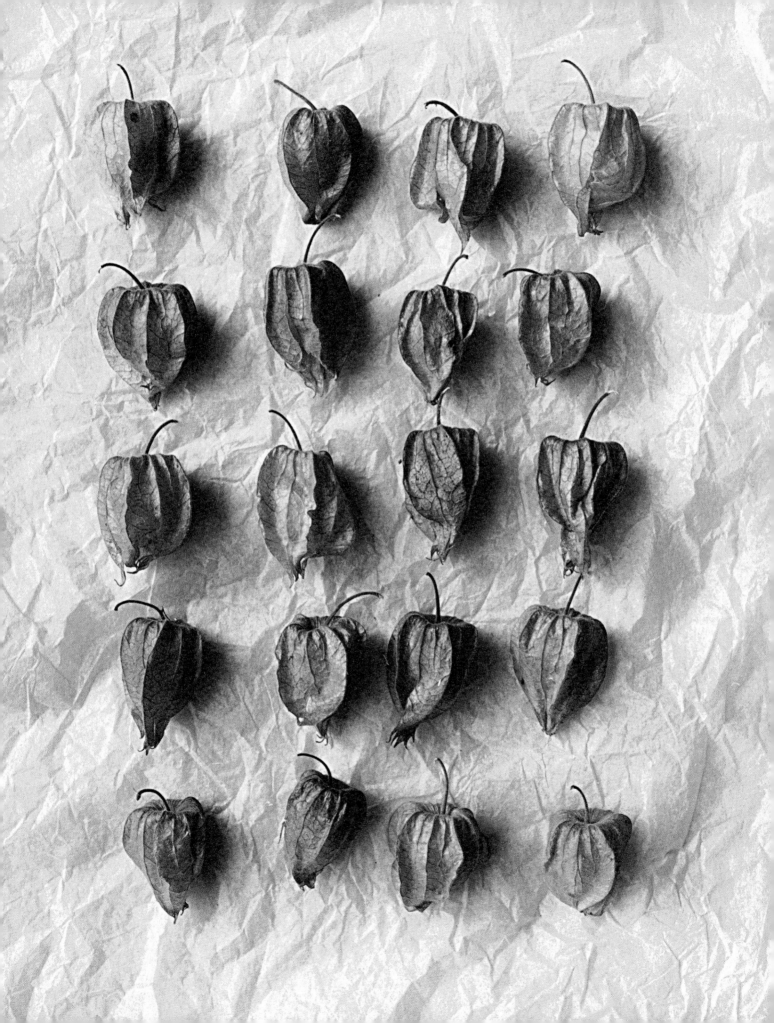

Copper toning

Copper (or red) toning is one of the easiest print-enhancing processes, yet it does not enjoy the same popularity of some other toners. This is a pity, because it does provide a balance to the others. The color red can mean very different tones to different people and, as we have seen with other toners, the degree of the color is governed by a variety of factors, such as the paper used and the freshness of the toner. The colors that can be achieved vary from a rich brown to a subtle pink, right through to a strong brick red. The secret is to experiment with a range of toners and papers.

WHILE COPPER TONERS are available from various specialist manufacturers—including Tetenal, Fotospeed, Film Plus, and Paterson—I prefer to mix my own. Although the commercially-produced versions are relatively inexpensive, they are supplied as two solutions that need to be mixed together just prior to use; once mixed, they have a relatively short shelf life. Generally, I am less than keen to mix my own toners, but this is one for which I make an exception. The raw materials are easy to buy by mail order, simple to mix, and are not as toxic as so many other toning chemicals.

Tate Gallery, London
When copper toned, the mid and high tones in this architectural detail seem to come alive.

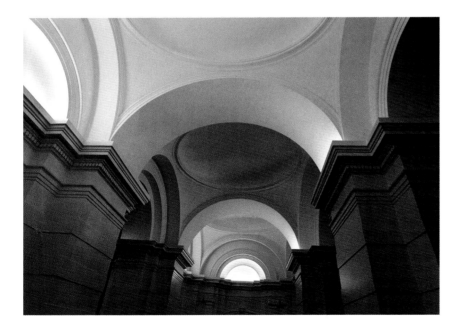

How to mix your own copper toner	
Solution A	**Solution B**
Copper sulphate 0.8oz (25g)	Potassium ferricyanide 0.7oz (20g)
Potassium citrate 3.5oz (100g)	Potassium citrate 3.8oz (110g)
Water 28fl oz (1 litre)	Water 28fl oz (1 litre)

The process

Unlike so many other toners, copper seems to work equally well on either RC or FB papers, which makes it a particularly flexible toner. Moreover, in common with so many other toners, it can work rather too quickly when freshly mixed, so I generally weaken the solution. Once the print is in the toner, it is important to maintain a gentle agitation to ensure even toning. You should start to see a change of color after a minute or so, particularly in the highlights. Gradually, the toner will start to work on the mid tones and then finally on the darks. However, I recommend exercising some restraint—the longer you tone in copper, the more the contrast is reduced and the blacks start to lose their intensity. You also need to appreciate that there is an optimum point in copper toning when toning ceases to work on the highlights and mid tones, but before the bleach overweakens the blacks. If you wish to retain the maximum tonal range, remove your print just as the mid tones are appearing to change color. With a freshly mixed solution, that may only take 2 to 3 minutes.

If you do not like what you see, this process is redeemable. Just wash your print and then put it into a solution of paper developer (normal strength). If you have only partially toned your print, it may come out lighter than when you first started. Wash your print, then try toning again. Once completed, all prints should be thoroughly washed (5 minutes for RC papers and 30 minutes for FB). Do not be alarmed if your print comes out of the toner with a surface

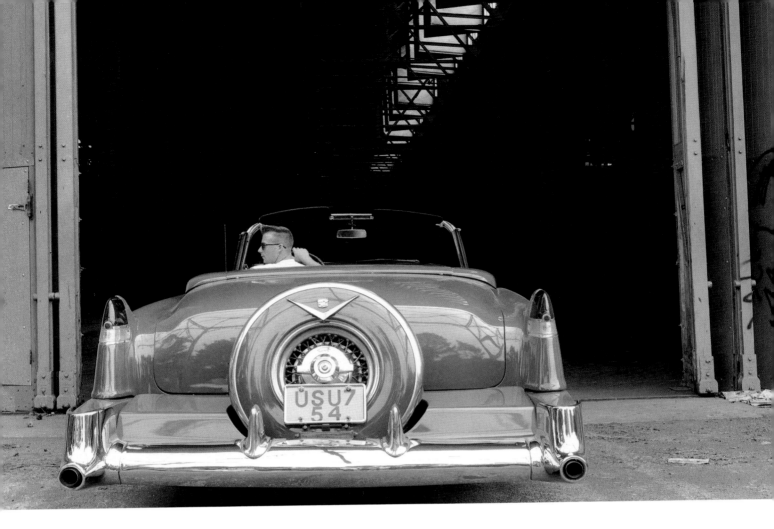

bloom; this can usually be removed with a quick wipe with a cloth. Gloss papers, and especially RC ones, are made duller by the toning process; for this reason I use a pearl or matte paper.

Intensifying the red

Boosting the color can be achieved in two ways:
1 Add potassium bromide to your toner. Mix up into a solution, and add about 1fl oz (25ml) per 28fl oz (0.8 litre) of toner. In this way you will achieve a far more robust red.
2 It is also possible to intensify the effect of the toner by toning your print as normal and then redeveloping it in print developer until it reverts back to its former black-and-white state. If you then retone it in copper, the intense effect will be greatly exaggerated.

Retaining the blacks

One of the main problems with copper toning is that that while it does appear to affect only the lightest tones at the earlier stages of the process,

it does start to lighten the darkest tones as well, thus reducing contrast. Occasionally that can work to your advantage, but generally that is not the desired outcome. There are two ways of overcoming this:
1 Give the entire print a brief soak in a selenium toner solution prior to the copper toning stage. The selenium will effectively darken the darkest tones, and also serves to block the copper toner from working on these areas. It is very important that you do not overtone in selenium, otherwise you will leave very little silver for the copper to work on. Similarly, it is important that you wash your print thoroughly after the selenium toning stage. This technique is an example of dual toning, which we will be examining in more detail in Part 2.
2 You might also try brushing a strong solution of print developer selectively into the darkest areas of the print. However, this does need to be done with considerable care, otherwise the effects will be far too obvious.

USU7

Copper is an easy toning process. The only problem is that it can degrade your blacks significantly if you tone excessively. One way to overcome this is to give your print a short selenium bath prior to toning.

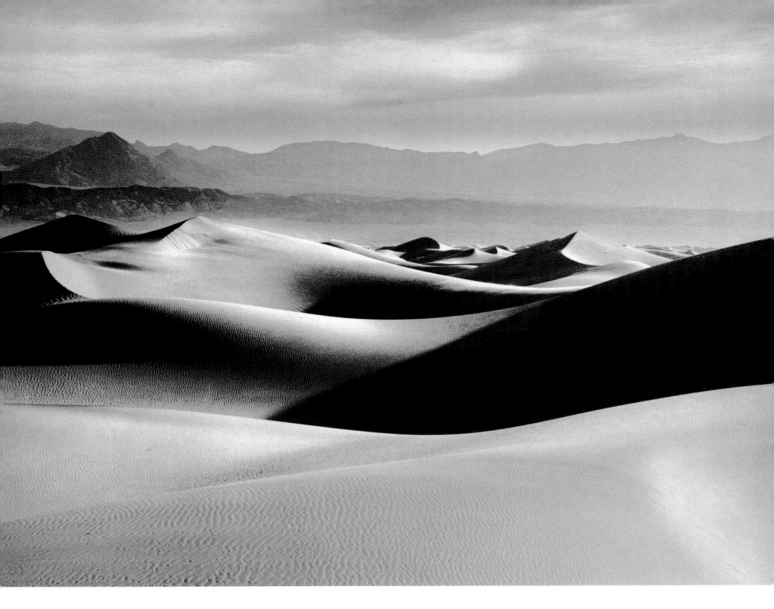

Undulating dunes, Death Valley

Working exclusively in monochrome can sometimes prove to be too restrictive. Death Valley is reputably one of the hottest places on Earth—by toning in copper, something of the overwhelming sense of wilderness of this wonderful place is communicated to the viewer.

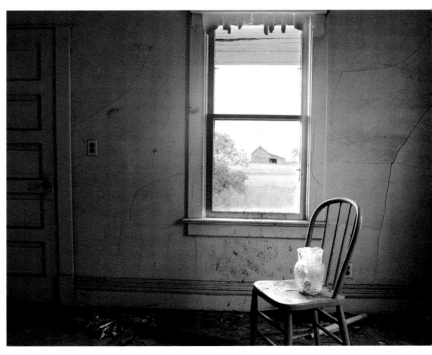

Jug on chair

VERSION 1 (RIGHT): One problem associated with copper toning is that it lightens all the tones, including the darker ones. If you tone vigorously, this is the price you pay.
VERSION 2 (FAR RIGHT): You need to keep a watchful eye on the darkest tones to ensure that they are not being unduly affected.

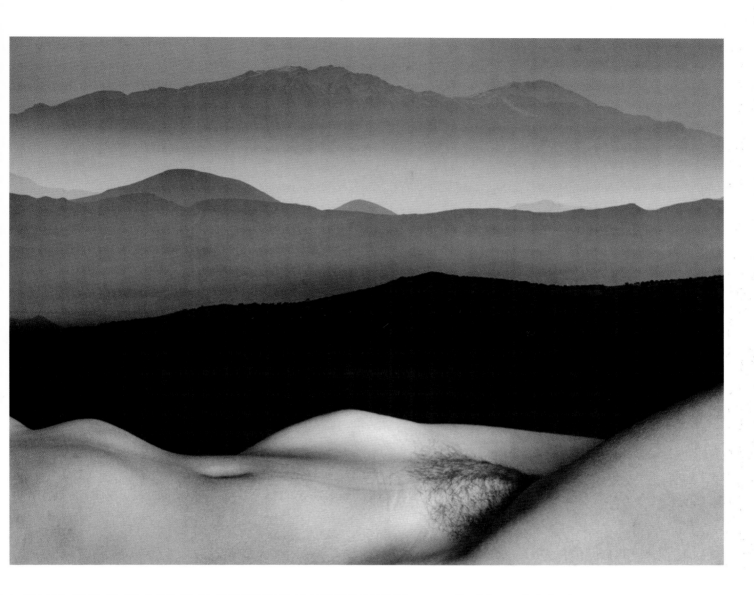

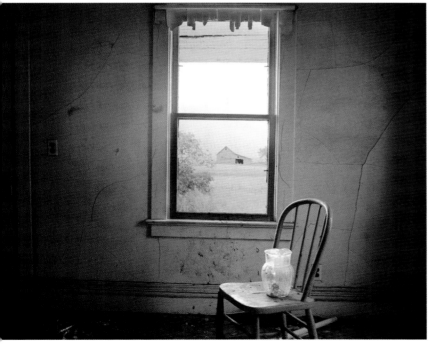

Reclining nude in landscape

The visual analogy between the human form and landscape can be quite strong, as this multiple print aims to show. While the print stems from two entirely different negatives, the strong toning has helped to unite the image more effectively.

POINTS TO CONSIDER
■ This is an easy toner to mix up yourself. ■ Your print needs to be 10 to 25 percent darker than normal, as copper toning lightens your print. ■ Copper red is one of the warmest colors in the spectrum, and you will need to judge with care which prints are most suited for this technique.

Green toning

While toning in sepia or blue has grown in popularity over the last few years, few printers ever try green. There are various reasons for this. There has been only a limited range of available toners, and some have proven unreliable and difficult to use. Once mixed up they do not store well. Furthermore, my own concern was that the greenish hue that most toners produced was flat and lifeless, and did not adequately reflect the large variety of greens commonly seen in nature. Green, of course, is not a primary color, but is a secondary color comprising blue and yellow; some greens also have a very slight hint of red, which makes the manufacturing of a green toner especially difficult. Fortunately, you now really can control the precise color you require, using the new generation of chromogenic toners, such as Fotospeed Palette and Tetenal Multitoner Kit.

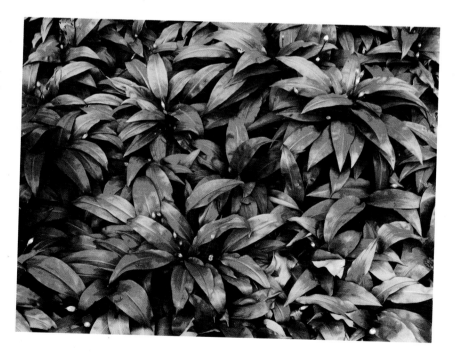

Ramson leaves

This was toned first in blue and then in vanadium yellow; as the process greatly lightens your print, start with one that is 50 percent darker than normal. This technique is particularly interesting, as you can achieve rather pleasing color demarcations between the pale yellow, bottle green, chocolate brown, and black. You must take care not to overdo this technique, otherwise the colors will start to solarize.

GREEN TONERS ARE are "hybrid toners" and are available from Speedibrews and Fotospeed. They come in three parts: part A is a bleach, part B is a yellow toner and part C is a blue toner. The shade of green is determined by the mix of B and C. The length of time you tone the print, and the extent you bleach it, also has an effect on the final outcome.

If you do choose to use this type of green toner, it is important that you start with a print that is at least 20 percent darker than normal, as the yellow toner has an enormous potential for bleaching out the light and mid tones. Furthermore, the more you bleach out, the more you reduce the contrast.

Intensifier—potassium bromide

If you wish to strengthen the tone of your green, add a small amount of potassium bromide to your toner; this is a useful solution to have available, as it is capable of intensifying most toners. To make a stock, add 3.5oz (100g) of potassium bromide to 28fl oz (0.8 litre) of water. To intensify toner, add 1.5fl oz (44ml) of this working solution to 14fl oz (415ml) of toner.

Some printers have experienced problems with green toners. While the whites look clean immediately after toning, they appear rather yellowish after washing. This can be caused by traces of iron in the water. The answer is to soak your print in a weak solution of citric acid—a spoonful per 14fl oz (415ml) of water works.

Fotospeed Palette toners

The big advantage of using multi-toners, such as Fotospeed Palette, is that you have an option of using one of two yellow toners provided—titanium or vanadium—increasing the color possibilities greatly. The titanium yellow produces an orange/yellow color, that introduces shades of brown in the shadow detail. The bleaching effect is quite dramatic, and you may need to print up to 50 percent darker than normal in order to retain detail in

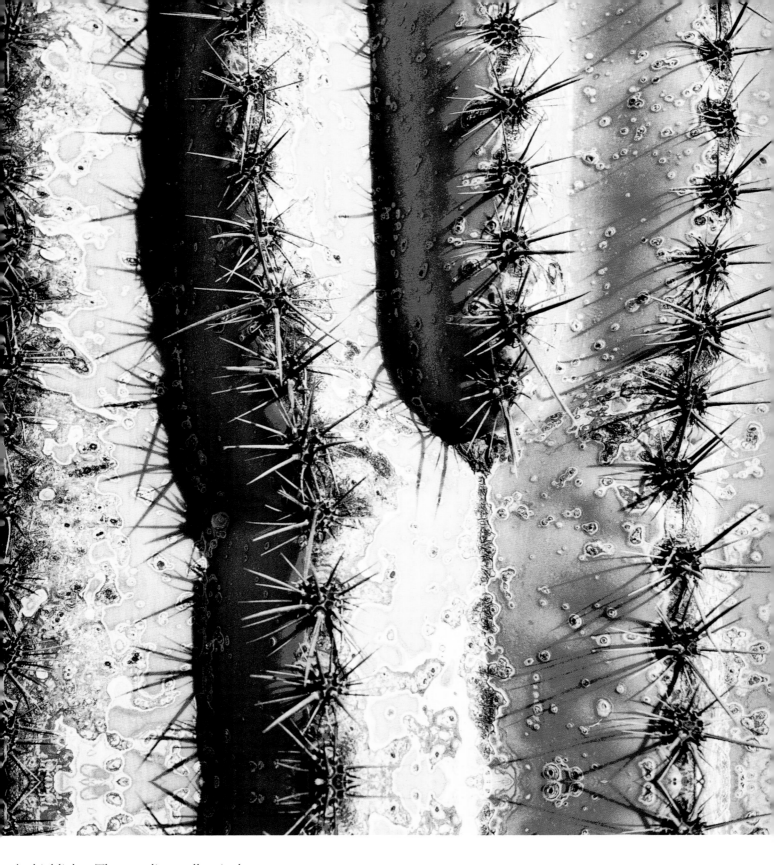

the highlights. The vanadium yellow is closer to a standard yellow, and while the bleaching effect is also quite strong, it is not quite so dramatic, although you will still need to print about 10 percent darker than normal.

Cactus

This print was first toned in vanadium yellow and then in Palette blue. Both toners were greatly diluted, exaggerating the split between the yellow brown, viridian, chocolate brown, and black. I have been fairly impressed by how many casual observers have remarked that they thought this was a color print.

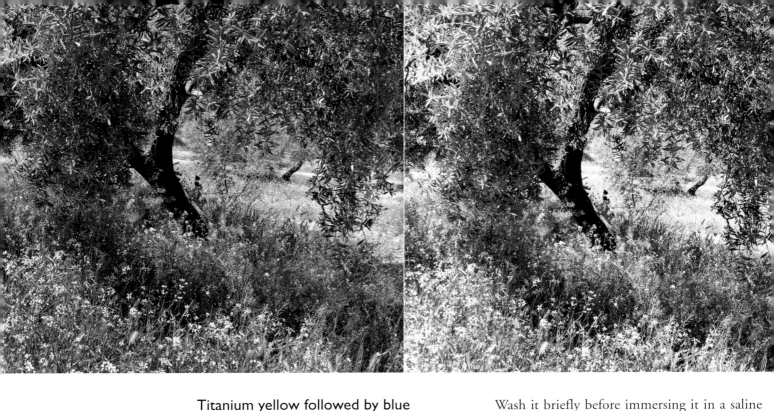

Titanium yellow followed by blue

This is possibly the best way of achieving a standard green, although the final color depends on both how long you tone your print in the titanium and then how strongly you blue tone it afterward. Generally speaking, a normally printed or slightly darker than normal print suits this combination.

Assuming that your toners are freshly mixed, you should tone your image cautiously, giving it 30 seconds to 1 minute in the titanium before removing it. Do not allow the print to go completely yellow, as it is essential that some of the silver is left for the blue toner to work on.

Wash it briefly before immersing it in a saline solution to clean up the whites. If you are using RC paper, then wash the print for a further 3 minutes, but if you are using FB paper, give it at least a 10-minute wash.

Wipe your print clean with a cloth and then place it in the blue toner. If you wish to maintain some of the original silver, keep a careful visual check on your print. It is always advisable to remove it sooner rather than later, because it is much easier to return the print back to the blue toner than redevelop in print developer and then start again. Once you have achieved the green you are after, repeat the washing process.

An interesting variation of this technique is to start with the blue, wash, and then place the print in a very weak print developer (try 1 part developer to 99 parts of water). The blue-toned print will very gradually start to revert back toward its black-and-white state; as soon as you detect this, remove it from the developer, wash it and then put it in the titanium. This produces a very rich and plausible green.

Blue then vanadium yellow

This process is virtually the same as the last one, although it is essential that you start with the blue. If you start with the vanadium yellow, you

Olive tree, Crete
This was strongly toned in Palette blue, and then toned in titanium yellow resulting in this rich viridian green. It does not take too much time to appreciate that chromogenic toners such as Palette introduce considerable scope for interpretive toning.

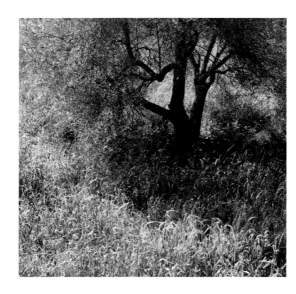

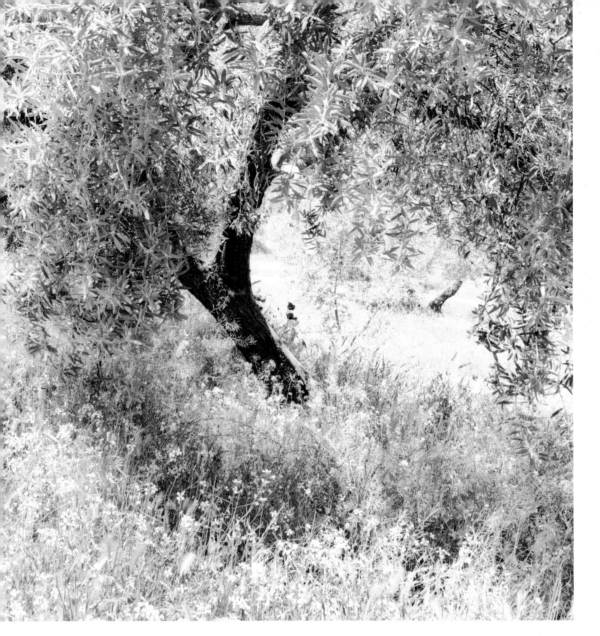

Olive tree, Andalusia
The Palette system offers
enormous scope for
personal interpretation,
as these three variations
illustrate.

In VERSION 1 (FAR LEFT),
I gave the print just 5
seconds in the vanadium
yellow and then toned it
fairly strongly in the blue.
The result is not too
dissimilar to a conven-
tional split between a
sepia and blue toner.
In VERSION 2 (MIDDLE
LEFT), I first toned the
image fairly positively in
vanadium yellow and then
toned it in blue.
In VERSION 3 (NEAR LEFT),
I toned the image in a
much-weakened solution
of Palette blue, and then
followed this with a
strong titanium yellow.

will get a rather unattractive solarized effect (the bane of other chromogenic dyes in the past).

You need to start with a print that is 50 percent darker than normal, otherwise you will lose your lighter tones. Tone your print blue, but again take care not to overtone. Wash and then place your print in the vanadium toner. The change can be quite dramatic, therefore it is important to remove your print before it becomes too yellow or too light. It is worth having a tray of clean water to hand in order to arrest the toning process at precisely the right time. The results can be quite spectacular, producing delicate yellow greens in the high-lights, deep bottle greens in the mid tones, and a rich, dark chocolate brown in the shadows.

Achieving gray/blue

This is a very simple technique that simply involves blue toning your print in Palette blue and then placing your print in a solution of diluted paper fixer. There are no rules here, as the process can be determined by eye. As the process will continue until the print has been in the wash for a few seconds however, it is perhaps worthwhile erring on the side of caution.

A slight and rather beautiful variation of the last technique is to very briefly place your print in a solution of the vanadium yellow (5 seconds at the most). Remove the print, wash it and tone it in Palette blue toner. The result is a subtle blue/gray tone with biscuit brown highlights.

FSA (formamidine sulphinic acid)

Speedibrews has developed a range of toners that work on a principle that is clearly different from all other toners. While one is able to achieve a large range of colors, the colors are all gained by using the same universal toner. I say "toner," but this is not strictly true. All conventional toners work by changing the silver into something else; for example, when you use a sepia toner, the process changes the silver into sulphide, whereas when you tone in selenium, the silver changes into selenide. The effect of the FSA process is to first bleach the print and then redevelop it as silver. The key lies in the bleach you use. This idea has been around for a while, but Speedibrews is the first company to exploit this commercially.

THE CHOICE OF three bleaches is fundamental to the FSA process. You pick either a bromide bleach, a chloride bleach, or an iodide bleach—each reducing the print to bromide halides, chloride halides, or iodide halides respectively. When the print is subsequently redeveloped in the universal toner, then the halides are converted into silver bromide, silver chloride or silver iodide. As each of these emulsions has different particle sizes, they have a different light reflectivity and are capable of producing different color hues.

You have the opportunity to produce an interesting range of colors—from brown, through sepia and orange, to brick red. And you are able to achieve much deeper blacks.

The results that you get will be determined by which bleach you choose to use: the cold bleach, the red bleach, or the sepia-styled bleach. In addition, colors can be changed by choosing a warm chlorobromide paper or a cooler bromochloride paper.

As an initial starting point, produce prints that are about half a stop lighter and one grade less contrasty than a normal print. Remember that FSA increases contrast and intensifies shadow detail.

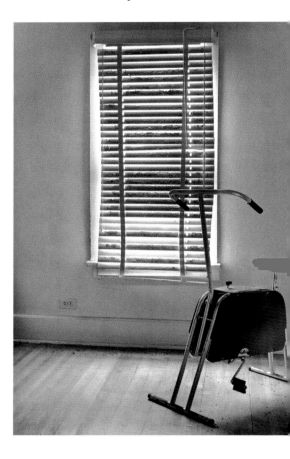

The exercise bike

VERSION 1 (ABOVE): This was partially chloride bleached, then toned in a weakened solution of toner for 2 minutes. To begin, the tones are cool but quickly become warmer and more intense the longer they stay in the toner.

VERSION 2 (RIGHT): This final image was strongly bleached, and then processed in the full-strength toner. Everything happened very quickly, and if you do want to control your toning, you may well be advised to use diluted solutions. Both versions were printed on Ilford MG FB IV.

FSA cold-style toner (chloride bleach)

The name of this toner is a bit of a misnomer, because you are able to achieve a particularly wide range of warm colors, starting with a mushroom color, right through to a vibrant brick red. Of the three available toners, this is probably the easiest to use and the most flexible.

You do, however, need to prepare for this toner because, once mixed, it does have a very

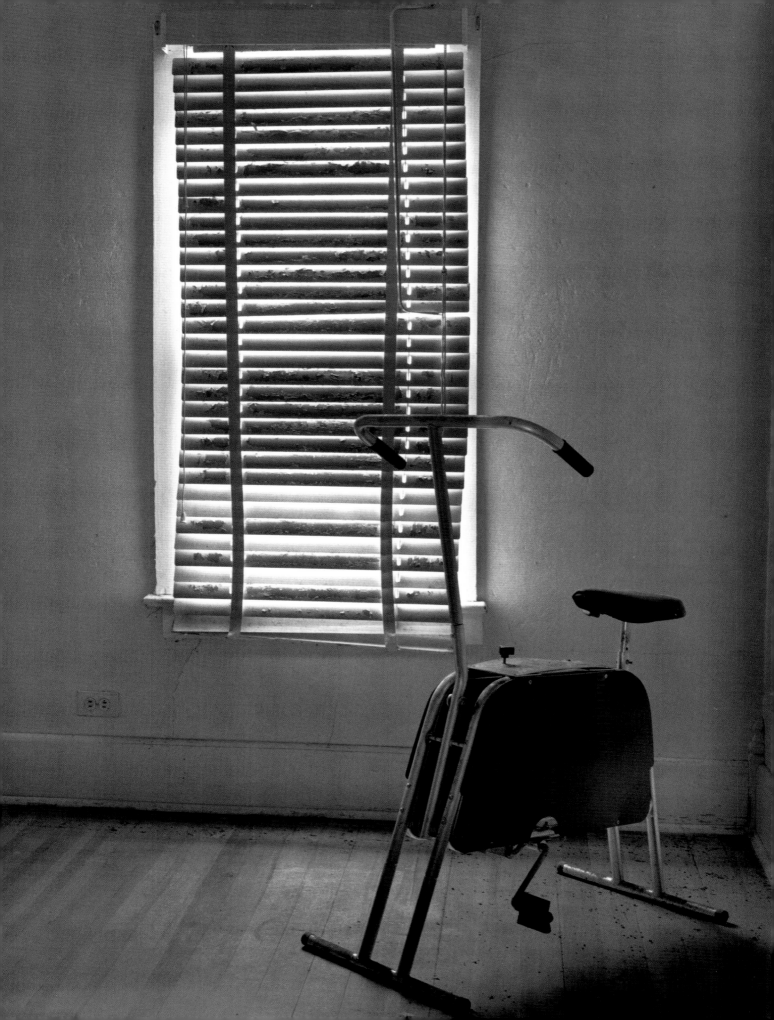

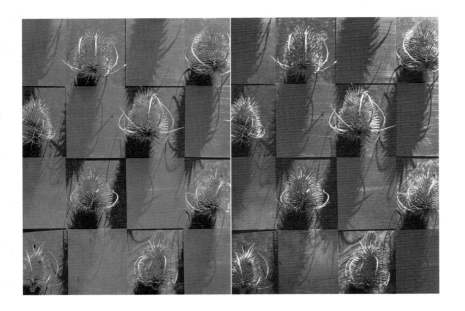

Teasels

VERSION 1 (FAR LEFT): This was partially chloride bleached and toned in a much weakened solution of toner. Initially, the areas that are least affected by the bleach appear gray at the early stages of toning, but this gradually disappears as the toner builds up intensity. It is a matter of personal judgment when you decide to finally remove the print from the toner. In this print, just a small amount of gray has remained in the lightest tones. Printed on Ilford MG Warmtone.

VERSION 2 (NEAR LEFT): Also printed on Ilford MG Warmtone paper, this image was strongly bleached and toned in a weakened solution, but for a relatively long period of time (over 5 minutes). As the toner worked on the print, the color got steadily more intense.

poor shelf life. Try to plan a session where you are able to put through between 6 and 10 12x16in prints—but remember that low-key prints tire out this toner far more quickly than high-key images. You will quickly learn which prints best work with this toner, and then save them and plan for one extended toning session.

To start off the process, place your print in the bleach, making sure that you agitate evenly.

You will immediately notice your print changing to a yellow/brown. You can either partially or completely bleach your print, depending on the final result you are after. After bleaching, wash your print for 10 minutes, then place your print in the toner; once again, it is important that you agitate regularly. The results now depend on what paper you are using, the density of your print, and how long you choose

Rex Cinema, Wareham, Dorset

This image was iodide bleached in a normal strength solution for just 1 minute. After a thorough wash, it was redeveloped in the universal toner for 5 minutes. During that period, it went through some interesting color changes—you decide when to stop.

to tone for. Initially it does appear to cool the tones, but very quickly this changes and much warmer hues begin to appear.

The decision of when to remove the print from the toner must be an aesthetic one, but if you get into the habit of toning your test strips beforehand, you will be able to make a much more informed judgment. After toning, you need to wash the print for a further 10 minutes.

Variations to try

■ Try changing the temperature of the toner. At 68°F (20°C), you will generally achieve a cool sepia tone. If the temperature of your toner is colder, while it will take longer to work, you should notice a lighter, redder hue. When the toner is over 68°F (20°C), the color intensifies.

■ The shade of the sepia can also be determined by the temperature of the developer used to produce the print.

■ Altering the strength of the toner can also have an effect. If you dilute it, the color becomes lighter and redder.

■ Try adding a small amount of paper developer to the toner; again, this results in darker colors.

■ Try varying the type of paper used; warm-tone papers can respond quite differently from neutral-based papers.

Passing storm, Colorado

This has been weakly bleached but strongly toned in FSA Sepia-Style Toner. The toner has had very little effect on the darkest tones or lighter areas, but the mid tones, by comparison, have turned a rich sepia/red, creating a most attractive split.

FSA red/orange toner (iodide bleach)

When compared to the cold-style and sepia-style toners, the red/orange-style toner is by far the warmest. The mixing and processing is identical to the cold-style toner, except that the bleaching and toning take considerably longer. Normally, I recommend that you dilute the bleach in order to gain greater control over the process, but not in this case; even a fresh mixture will take up to 10 minutes just to partially bleach a print.

The greatest variable you have with this toner is the paper you use. It is even affected by the grade of paper, therefore it is worth experimenting with a variety of papers to find the combination that most appeals to you.

Try bleaching but not toning afterward; you can achieve some remarkably beautiful results. You will need to start with a fairly contrasty print, and particularly one showing strong shadow detail. The bleach attacks the darkest tones first, changing them to a rich, gingery brown, while the lighter tones remain gray. You can vary this technique by putting your print back into the toner, but only leaving it in for a very short period of time. You will start to notice some very subtle color changes in the lighter tones, with colors ranging from blue/gray to yellow and pink. If bleached to extreme, you will notice a dramatic solarized effect that you might find interesting.

In common with the cold-style toner, the effect can be varied through the temperature of the toner, the dilution of the toner, the length of the bleach time, or whether you add a small amount of paper developer to your toner. The results are so varied it is impossible to itemize them all, but once again I can only recommend that you try them out and see.

FSA sepia-style toner (bromide bleach)

It is important to remember that this is not a sepia toner, even though, superficially, the results do look similar. It is entirely consistent with the other FSA toners, so you do need to be aware that you have only quite a restricted "window of opportunity." You are required to mix the toner 1 hour before using it, but you can expect to see it deteriorate after only a few hours use.

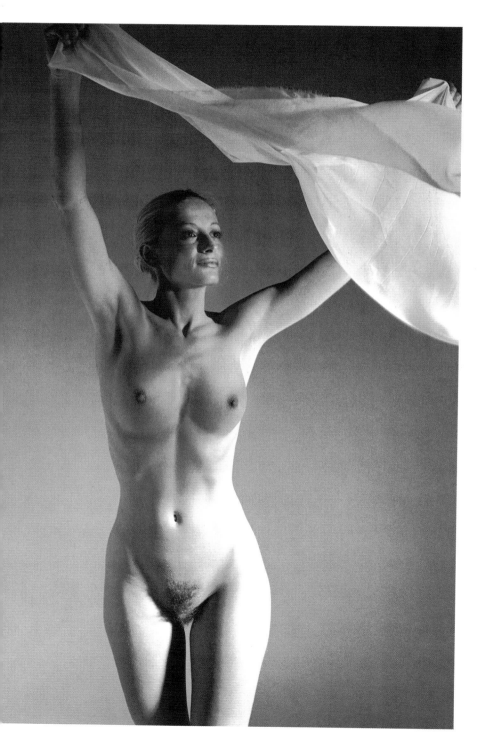

Model with light material
While there are similarities between this toner and sepia, with FSA you are capable of achieving much stronger hues without degrading the highlights.

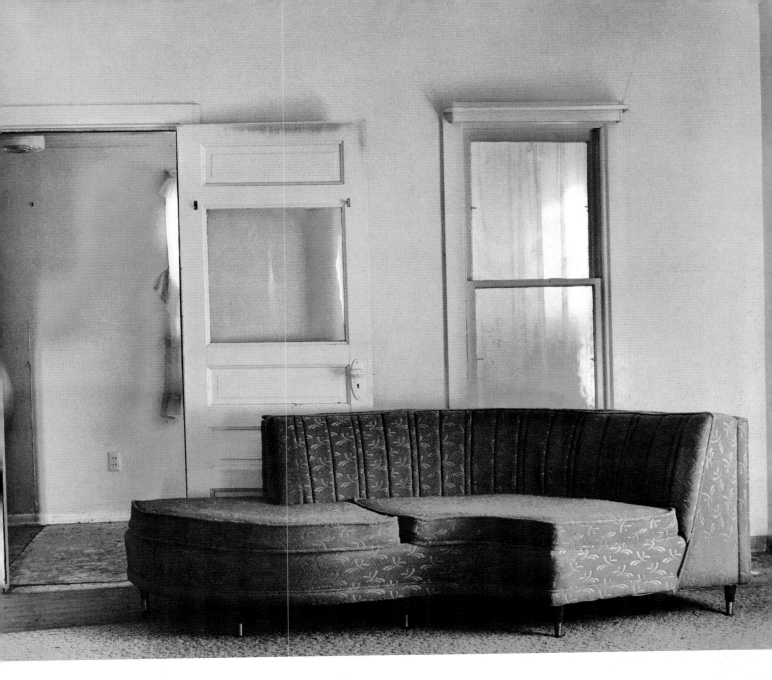

Despite these drawbacks, this is a particularly beautiful toner to use. There are similarities with the cold-style toner with regard to the aggressive nature of the bleach, and once again I would recommend that you use it at half strength; diluted this way, a print that is partially bleached takes about 30 to 40 seconds. If you wish to bleach to completion, it should take no more than 2 to 4 minutes, depending on the print density.

Variations to try
■ The temperature of the sepia-style toner appears to be an important element of the process. While it is designed to work at 68°F (20°C), it is just as capable of delivering excellent, although different, results at other temperatures. Higher than that, and the color gains more depth, while cooler temperatures produce lighter, redder tones.

■ Try partial bleaching and then toning to completion. This variation on the technique can offer some of the most interesting results— the darkest tones retain something of their original monochromatic qualities, as indeed do the lightest tones. It is therefore the mid tones alone that assume the rich red/sepia color that characterizes this toner.

Sofa
This image was iodide bleached in a weakened solution, but not to completion. The process revealed some extremely interesting colors, which suited this abandoned interior. I then toned it, but only very briefly, thus retaining many of the colors I saw at the bleaching stage.

PART TWO
DUAL TONING

While toning prints can be a relatively straightforward process, split toning and dual toning demand considerably more care. The results, however, can be astonishingly beautiful—and if you are successfully toning prints, then this next step should not prove too difficult. Split toning simply means allowing the toner to affect only parts of the print—either the lighter or darker tones. The resulting print shows characteristics both of a toned and an untoned image. Taking the technique a little further, you have the option of allowing these unaffected parts to be toned by different type of toner, thus creating a dual-toned print.

Dawn over Rannoch Moor

This image has been lith toned using Kentmere Kentona paper, and then split toned, first in selenium and then in gold toner. The huge advantage of lith is that you can achieve dramatic contrast in the shadow areas yet retain delicate and subtle highlight detail. But when you subsequently dual tone using selenium and gold, then this truly is a technique that is worth pursuing.

Introduction to dual toning

DUAL TONING WORKS best when you are using two toners that work from opposite ends of the tonal spectrum—one that works from the darkest tones first, together with one that starts to work from the lightest tones. Once this principle is understood, it is important to allow the toner that works on the darkest tones first only to affect the shadow tones. If you then place your print in a second toner, the previously toned areas will act as a block to this second toner, and you will have two distinctively toned areas.

However, if you are able to restrict the first toner just to the darkest tones while ensuring that the second toner only affects the lightest tones, then the mid tones will remain unaffected by either toner, thus creating three distinct color bands; this is known as a triple split. While in practice this is very difficult to do, there are ways of achieving it.

You will need to develop a keen eye; timing seems to have very little relevance with dual toning, as many toners tire easily, and even the slightest tonal variation in your print can affect how it will finally split. You will discover that you are subject to so many variables, including whether you use a warm- or neutral-tone paper, the paper developer you use, the temperature and dilution of the toner, and whether or not the toner is fresh. Add to this the need to bleach with some toners, and you can appreciate that you will encounter some unexpected surprises. But that's the joy of dual toning!

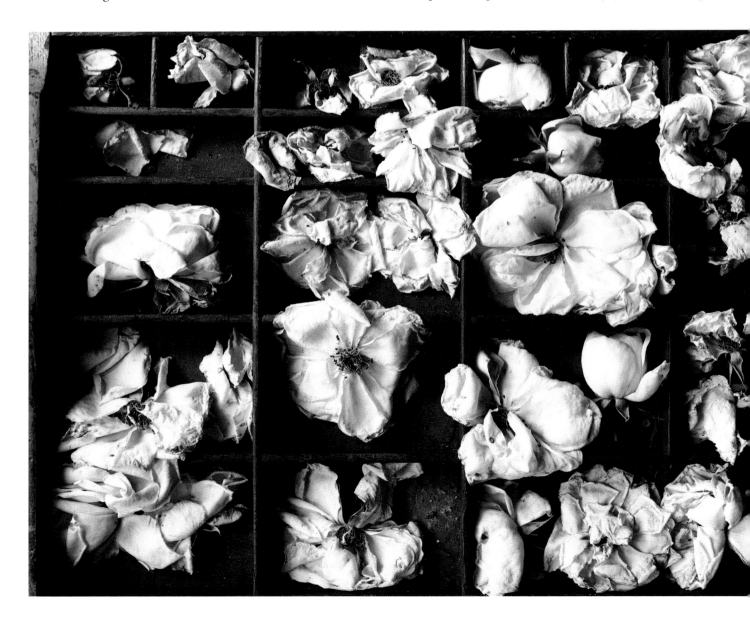

Another challenging aspect of dual toning is the need to establish a visual balance. When using a single toner, you can decide to what extent you wish to tone. You may care to partially tone, or to tone to completion. When dual toning, you have the same kind of options, except this time it involves two toners. For example, you may wish to tone very slightly in one, but very heavily tone in the other. Conversely, you may wish to tone lightly in both, and as you experiment, you will come to appreciate that there are many different permutations from the basic techniques.

When you then consider that we looked at 13 different toners in Part One, and that potentially each toner could work with the others, the permutations must seem endless. Sadly though, not all toners work together well. What I have attempted to do in this section is to consider some of the classic combinations, as well as explore some unusual techniques. In no way is this a definitive list, and even as I write, friends and colleagues continue to alert me to new possibilities, but once you have understood the principles underlying dual toning, you will discover combinations that uniquely complement your own individual style of printing.

Printer's tray with roses

VERSION 1 (OPPOSITE): A neighbor was about to throw away these rose heads, but I managed to persuade him to let me have them, and I then carefully arranged them in an old print tray. While the roses are past their prime, they assumed a new kind of beauty as they started on the path toward deterioration and decay. I printed this image on a warm chlorobromide paper.

VERSION 2 (BELOW): This image has been quite strongly toned in selenium and then toned in copper, adding warmth to the lightest tones. It is not always necessary to achieve a dramatic split.

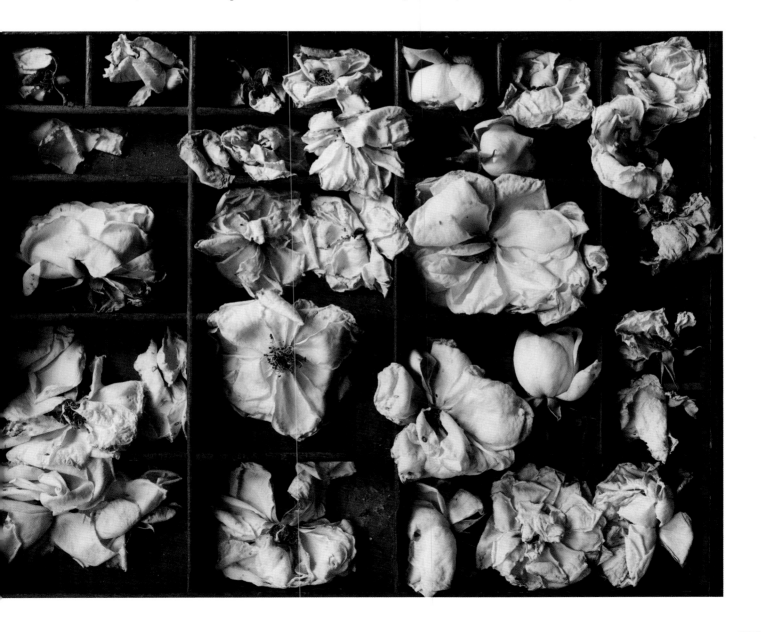

Sepia then selenium

In many senses, this is the classic split-toning process. While the colors do not rival some of the other more "showy" processes, this is a particularly useful means of introducing tonal control. Moreover, as both sepia and selenium are archival toners, this is the dual-tone process you should use if you want your prints to last for decades (and, hopefully, even centuries).

Pisces

This print is rich in texture—a visual quality that all dual-toning techniques seem to enhance. I bleached the print sparingly, and then toned it to completion in a weakened sepia toner in order to achieve rich biscuit tones in the highlights. I then toned the print in selenium diluted 1:20.

THIS PROCESS SEEMS to suit most of the subjects that work well in monochrome. However, it does produce a warmth that may well preclude some themes commonly associated with cold. But my main reason for using this process is that it expands the tones of a print and thus increases contrast.

You will have discovered that when using a sepia toner, that the tones of the image are lightened, although when using selenium, there is a slight darkening of the tones. By allowing the sepia to affect only the lighter tones, and then leaving the selenium to work on the rest, there is an inevitable increase in contrast.

The process

You can start with either the sepia or selenium, although the results will be slightly different. If you have a print with weak shadow detail, start with the selenium and tone the print until the tones visibly darken—but remember that the maximum D-Max is usually achieved after only 2 or 3 minutes; also, do not allow the selenium to affect the mid and lighter tones.

After toning, wash your print thoroughly, remembering that with FB papers this may take up to 30 minutes. Then put your print in the sepia bleach. While it may not have been obvious prior to bleaching, you will immediately see the effects of the selenium toning at this stage. You can afford to bleach quite strongly, as this will not affect those darker areas that have been selenium toned. Wash your print, and then tone in sepia.

Once the whole process is completed, thoroughly wash your print again, and when dry you should see a warm-toned print revealing a wider range of tones.

If you decide to tone your print in the sepia toner first, it is very important that you do not overbleach. As a general guide, once you can detect even the slightest color change in the lighter tones, then you have bleached your print sufficiently. After a brief wash, put your print into the sepia toner, but if you wish to maximize the appearance of a tonal split, use a much weakened solution. When you remove your print, it should appear just lightly sepia-toned. Wash your print thoroughly, and then place it in the selenium. This can only work on the darker tones, but the print should be removed once the maximum print density has been achieved. If successful, you should achieve delicate golden tones in the highlights, contrasting with rich, cool blacks in the shadows.

While the process works equally well with both RC and FB papers, the split is far more evident with neutral or cool papers.

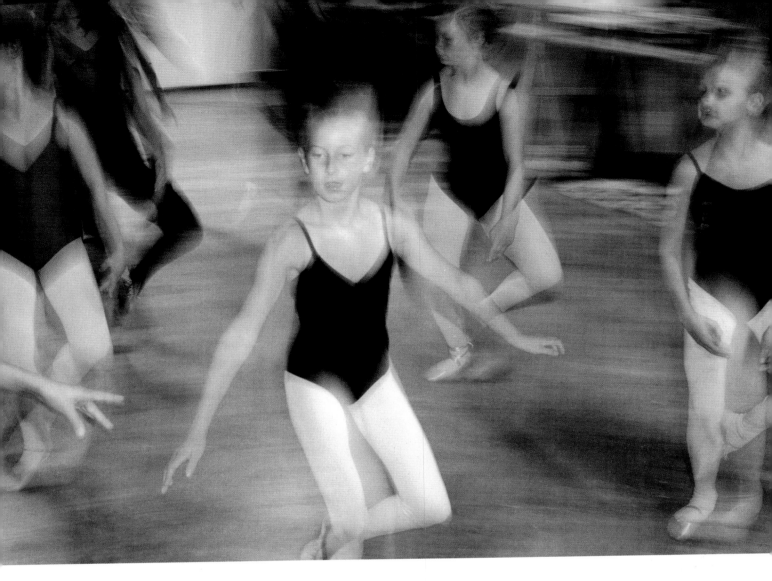

■ You can work either way round—toning in the selenium first and then in the sepia, or in the sepia first and then in the selenium.

■ This process works equally well with either RC or FB papers, but is more effective on cool-toned papers.

■ This is almost the ultimate archival toning process.

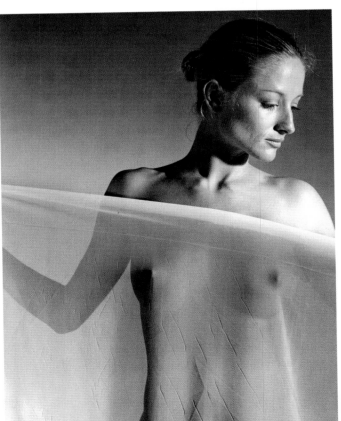

Dancing school

By splitting the tones using sepia and selenium, this image conveys clarity and warmth.

Torso seen through translucent material

When dual toning an image, the split can be dramatic or, as in this case, very subtle. The darker purple tones induced by the selenium gradually give way to the lighter biscuit of the sepia.

Sepia then blue

This dual-toning combination is one of the most popular techniques with experienced darkroom workers—partly because both sepia and blue toners are cheap and easily available from photographic stockists. But it is also because the blue will affect the darker tones, while the sepia works on the lighter areas, resulting in colors that are very typical of many landscape scenes—especially those compositions in which the sky is a dominant feature.

POINTS TO CONSIDER

■ Always start with the sepia, not the blue.

■ Do not overbleach at the sepia toning stage, otherwise your blue will show a strong bias toward green.

YOU DO NOT need to be too fussy about the tonality of your print before you start with this technique. The sepia will lighten the highlights, while the blue will darken shadow detail, so I generally start with a print showing normal tonal values.

If you are keen to establish a clear-cut distinction between the sepia and blue, it is worth starting with a relatively contrasty print, although I have seen some excellent results with prints displaying a very narrow tonal range.

It is important to start with the sepia. In the section on sepia toning in Part 1, I suggested that very interesting results could be achieved by using very weak solutions of bleach and toner (so as to only to partially tone the print sepia). This is precisely how you should start the first stage of this process.

Dilute your bleach to a strength far weaker than the manufacturers recommend, and then put your print into the bleach, but only allow it to remain there for a very short time. Try to remove your print before there is any visible change of color. After a brief wash, place your print in the sepia toner, but once again in a much diluted solution. Wash your print again, then place it in the blue toner, but, as always, I would strongly recommend caution, because if your print remains in the blue toner for too long, the toner can easily overwhelm the delicate sepia tones. Timing each procedure is virtually useless, so rely on eyesight alone.

Deserted beach, Crete

VERSION 1 (RIGHT): An untoned print. When shooting this scene, my eye was drawn to the naked umbrellas, which look like modern sculptures. However, because of the flatness of the tones, this print lacks visual excitement.

VERSION 2 (ABOVE): Dual toning with sepia and blue can often work well in landscapes taken in overcast lighting. While the shadows in this scene remain blue, the lighter areas of the beach assume a natural sandy color. When planning to dual tone, it is important that you consider how the constituent parts of the print will be affected; for example, if the sea in the distance had turned sepia, then the image would have looked less convincing. Sometimes it is necessary to print quite purposefully for the dual-toning process, in order to establish the right balance.

Weymouth beach

Learning what will and what will not work with any dual-toning combination is part of the learning process. Blue skies with dramatic cloud formations work particularly well with this technique, because the blue works on the blue part of the sky while the sepia affects the clouds.

If the highlights seem a little stained by the blue, place your print in a weak saline solution, and that should clear them almost immediately. Finally, wash your print as normal, but take care not to wash the blue out. One note of caution: if you have a print that displays very dark areas adjoining white areas, it is possible that the blue will bleed into the white. The saline solution will remove some of this, but not all. Some see this as a hallmark of the technique, others see it as a nuisance; but if you are troubled by this, then try working on a less contrasty print.

As I have already suggested in Part 1, toning in sepia then blue is a standard way of achieving a green. However, the green you achieve when toning with sepia then blue is a relatively limited hue and does not compare to the wide variety of greens that it is possible to achieve when using chromogenic toners.

In order to achieve a green, you will need to be far bolder with your toning, although I would still recommend that your sepia toner remains relatively weak. You can intensify the green color by trying various alternating sepia and blue baths, although the color achieved obviously depends on the final balance between the sepia and blue. The final color of the print often resembles an olive green.

Deserted fairground

Images showing strong tonal contrast work particularly well when splitting between sepia then blue. The intricate detail in the central column particularly lends itself to this treatment.

West Pier, Brighton

When dual toning, it is important to keep an eye on the parts likely to be affected. While having some sepia in the highlights on the water works well, it is important that the majority of the sea is toned blue. Establishing the right balance is critical to this technique.

Selenium then blue

If done well, this technique is almost indistinguishable from selenium then gold (a process we shall be exploring later in the section on lith printing)—except that this is a considerably cheaper way of doing it. There are also similarities to sepia then blue although, tonally-speaking, the effect is reversed. Here, it is the lighter tones in the print that turned blue.

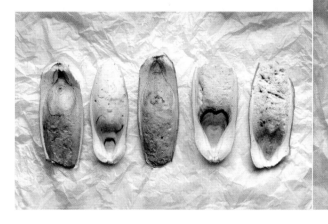

Meadow, Majorca
This landscape was taken on a spring day. When toned blue, it appeared too cold, but when brown tones are added, it assumes a much stronger visual balance.

IT IS ESSENTIAL that you start with the selenium toning process for this technique. I tend to get my best results using a fresh solution, diluted 1 part selenium to 15 parts water. Timing this part of the process is largely irrelevant, because it is determined partly by the strength and age of the selenium, but also by the density of your print; you are, therefore, far better off just keeping a watchful eye. Any color changes start to become noticeable in the darkest tones and then gradually start to affect the mid tones, although it is much easier to see this process happening when using a warm chlorobromide paper.

It is important that you remove your print at the critical point, as this process is irreversible. Furthermore, once all the silver salts have been converted to selenium, there will be nothing left for the blue toner to work on. On completion of the selenium toning, wash the print thoroughly.

At the blue toning stage, once again I recommend that you use a fresh, but weakened, solution, as blue toning can sometimes occur far quicker than you want and you, therefore, run the risk of overtoning. This should be avoided, because with this process, the blue should

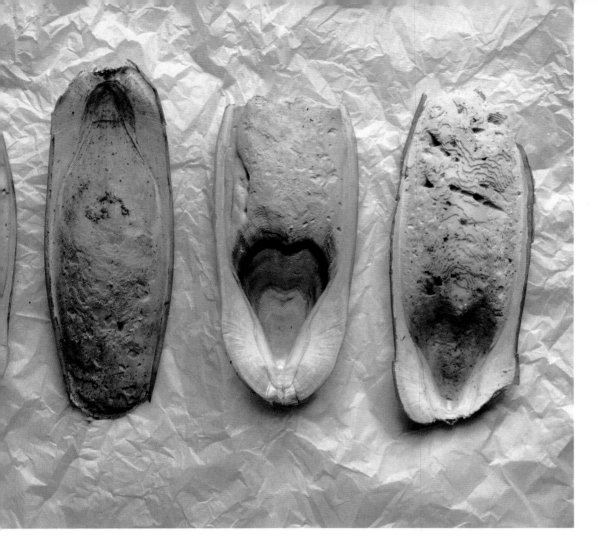

Cuttlefish

VERSION 1 (FAR LEFT):
This is the untoned print.
Try to keep your prints
on the light side.
VERSION 2 (NEAR LEFT):
Dual toning brings out
textural detail that is
not clearly apparent
in the untoned version.
The process has also
darkened the print.

represent the lighter tones in your print. Make sure that you have a tray of water on hand in order to halt the process at just the right time.

What can go wrong?

The most common mistake is to misjudge the balance between the brown and blue tones. This can be most apparent in areas of sky. It is a good idea to produce several identical prints before you start toning, and if you make a mistake with your first print, with just a few adjustments, the second one normally comes out well.

Sometimes the print does not turn blue after the selenium stage. This can often happen when printing onto a cooler paper simply because it is difficult to see the changes at the selenium toning stage. If you do overtone, then there will be no silver salts available for the blue toner to work on.

Stains, particularly in the blue areas, can also prove to be a problem. This can be caused by

Dead bird

As soon as I toned this
print, the parallel I saw
with brushstrokes in a
modern painting became
much more apparent.
This is partly due to the
somber colors.

various reasons, but the most common of them is that the print has been inadequately fixed or inadequately washed.

Selenium then porcelain blue

While this may appear to be just a minor variation on the selenium then blue process, the results that you can achieve are distinctly different. The selenium then porcelain blue process is also a more difficult one, but if you persevere, you will be rewarded with some beautifully dual-toned images. Because of the delicacy of the porcelain blue, this technique works particularly well in landscapes, especially where a watery-blue sky is required, or where you want threatening brown clouds to contrast with subtle blue highlights.

Truck stop, Oklahoma

This is a relatively difficult, but exceptionally beautiful, dual-toning process. You need to take great care at the printing stage to ensure that the tones are distributed in a way that will aid the division between the blue and brown areas. At the selenium stage, I was able to see the selenium affect the darker parts of the vehicles and then start spreading into the sky. At this point, the print was removed, washed and then toned in the porcelain blue.

A S THE BLUE has a tendency to lighten the tones, start with a print that has been printed between 10 and 15 percent darker than normal. It is important that you print in both highlight and shadow detail; use FB papers.

The process

It is very important to prepare your toners before you begin. Unlike most blue toners, porcelain blue requires a pre-toning bleach, which means that this dual-toning process needs to go through three stages: the selenium toning stage, the bleaching stage and, finally, the blue toning stage. Because of the number of chemicals that you will have to use, it is a wise precaution to label clearly each of your trays before you start.

Use warm-tone FB papers if you can so that you can see to what extent the selenium is affecting the print. If you undertone, very little brown will appear. As the selenium works from the darker toward the lighter tones, you should see a subtle change of color as the blacks and grays change to brown; removing your print at precisely the right time is crucial.

Now wash your print thoroughly for up to 30 minutes to ensure that all the selenium has been removed. Put your print into the bleach because fresh bleach can be rather fast-acting, I recommend diluting it to half the recommended strength.

Poplar trees, Spain

VERSION 1 (TOP LEFT): Untoned print. This shot was taken while lying on my back, gazing up at the tops of these beautiful poplar trees and deep blue sky.

VERSION 2 (TOP RIGHT): Partially selenium-toned print. The toner has affected the tree trunks and the darker bottom right corner. Using a warm chlorobromide paper helps, because you are then able to see the areas affected by the selenium.

VERSION 3 (BOTTOM LEFT): After the print has been in the porcelain blue bleach. At this stage it is impossible to see which areas have been affected by the selenium, as the bleach also turns the print brown.

VERSION 4 (BOTTOM RIGHT): The print split between selenium and porcelain blue. The longer you leave your print in the porcelain toner, the bluer and darker it becomes. It also darkens as it dries, so err on the side of caution.

At this stage, the areas affected by the selenium become even more apparent, changing to a strong rich tan, while the areas to be toned blue will lighten and assume a subtle chestnut color. After bleaching, wash your print for 10 minutes.

The toning stage is a relatively easy process, although you will need to develop a relatively keen eye concerning tone and color.

As soon as you put your print into the toner, the bleached areas will gradually turn a lightish green, slowly changing to blue the longer you leave it in. Judging the precise hue is quite difficult, as the print both darkens and turns bluer as it dries.

This decision is not made any easier because the toner has a slightly yellow color that makes the print appear more stubbornly green than it actually is. But do not be put off. This technique can produce prints showing great subtlety, and is well worth mastering.

Viradon then blue

This is possibly the most unusual of the blue/brown toning combination; nevertheless, it is one that is well worth exploring, especially when toning landscapes. The quality of blue that can be achieved with this combination is superior to that produced using similar processes.

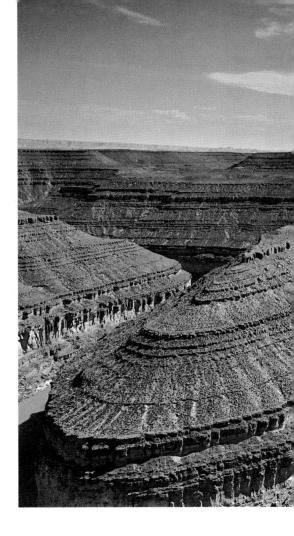

POINTS TO CONSIDER

■ It is easy to achieve a distinct split between the sepia and blue when using this process.

■ As the Viradon works relatively slowly, it is an easy process to control.

■ It is an excellent process to use with landscape subjects.

YOU WILL NEED to be aware of the fundamental characteristics of this process, before you kick off:

1 First, while Viradon has very little effect on the tonality of the print, blue toners do.

2 Second, while Viradon occupies the lighter tones, the blue works on the darker tones. Therefore, the ideal print to start with is one with positive tones in the highlights and mid tones, but with obvious detail in the shadows.

3 As this is a technique that expands the tonal range, using a soft-grade paper at the printing stage is advisable.

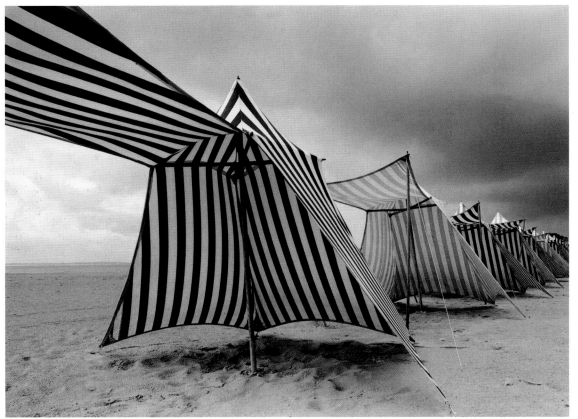

Beach near Royan, France

As Viradon is such a stable and enduring toner, it was possible to time the Viradon toning stage with this print. This made it much easier to determine where the blue/brown split was going to be.

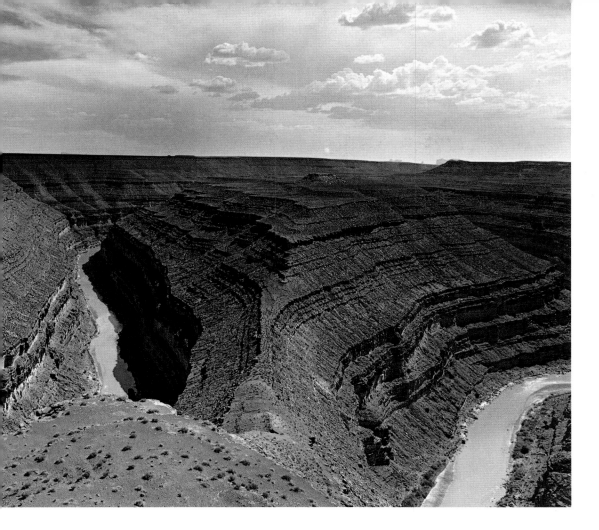

Goosenecks, Utah
In common with various other split-toning techniques, Viradon then blue works well with landscapes—especially if you have a dramatic sky. The brown Viradon works on the clouds, while the blue picks out the darker areas.

The process

After soaking your print, put it in the Viradon toner. The speed of toning is dependent both on the age of the toner and its strength; I generally dilute 1:50, but compared to many other toners, the process is slow, so be prepared to allow between 5 and 10 minutes.

The big advantage is that you can clearly see the changes. When you think that your print has been sufficiently toned, wash it thoroughly and then put it into the blue. One thing I have discovered is that Viradon is a stable and enduring toner, so it is possible to time it. Moreover, unlike sepia, it does not appear to mix with the blue, so it is easy to establish clear and distinct areas of blue and light brown.

Suitable subject matter

I find this an ideal technique for illustrating cloud formations set against rich blue skies. It is important at the shooting stage, that you use either a red or an orange filter, in order to get more tonal clarity in your negative. I am particularly fond of the rich Oxford blue that can be achieved when using this technique. The lighter hues that can be achieved are very similar to skin tones, and as long as you do appreciate that the darker tones will go blue, this can be a worthwhile avenue to explore.

Almond trees, Spain
The effects you get with Viradon and blue are not dissimilar to those achieved with sepia and blue—except that this is an easier process to use.

Copper then blue

The more I use this process, the more I appreciate it for the sheer flexibility it offers. While it works extremely well in landscapes, it also suits still-life images and interiors. In fact, it is difficult to find a subject matter that does not suit this enchanting technique. Its main characteristic is that while the copper renders the lighter tones a beautiful peachy/pink, the darker tones assume a strong navy blue. As copper has the effect of lightening tones, while blue darkens them, try starting with a low-contrast print. Note that where you have a very dark area alongside a very light area, there is a tendency for the blue to bleed into the highlights; washing does not always remove this.

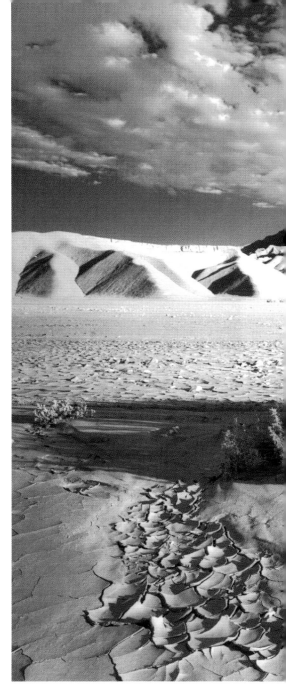

POINTS TO CONSIDER

■ Split toning in copper then blue is a relatively easy technique, and if you are a newcomer to dual toning this may well be the one with which to start.

■ It is a process that seems to suit a wide variety of subject matter.

■ Both toners can be intensified by adding a small amount of potassium bromide.

Model with turban

It is easy to establish the correct balance between copper and blue. Beginning with the copper will initially affect only the lighter tones (it is a matter of judgement when to remove it), leaving the remainder to be toned blue.

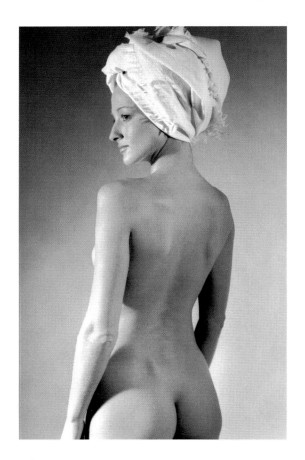

Generally when dual toning you need to be very careful about which order to tone, but with this process it is not so critical. All you need to understand is that the blue will work on the darker tones first, while the copper starts working on the lighter tones. Also, as the colors change quite obviously, it is easy to monitor progress. However, it is important to appreciate that the results will not be quite the same, depending on whether you start with the copper or blue, even though both methods work. Experiment to see which order you prefer.

Washing between toners is, of course, essential. If you are using FB papers, then I would recommend that you wash for at least 10 minutes, although if you use RC papers, then washes of 2 to 3 minutes should suffice. A saline bath between toners also helps enormously.

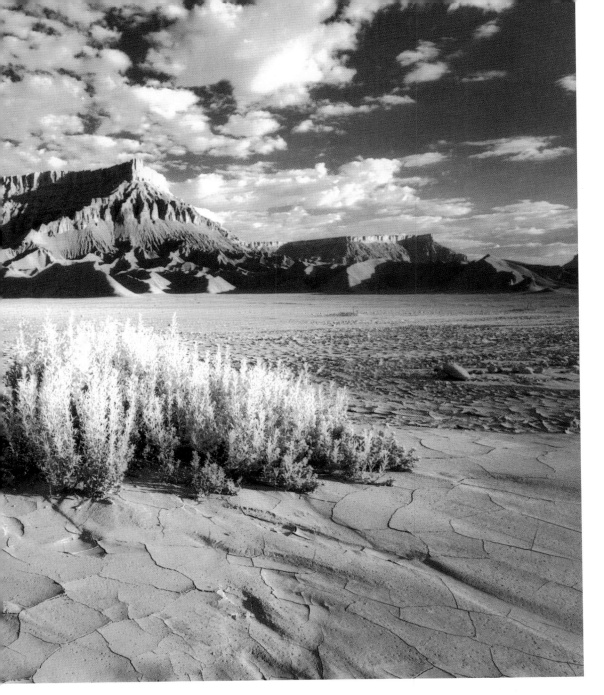

Butte near Hanksville, Utah
With all dual-toning techniques, it is not always necessary to balance out the affected areas equally. In this example, I only allowed the copper to change the lightest tones; in this way, you can create an almost sepia and blue effect.

Colorado River near Glen Canyon Dam
In all split-toning techniques, it does help if the colors you achieve with the process do approximately parallel what you may expect to see in nature. This was taken in a famous red rock area.

One of the biggest advantages of split toning in copper then blue is that it does allow you to repeat the process without ruining the print. This means that you may wish to start by toning very subtly, and then assess the print at that stage; if you sense that you have been too cautious, then you can return it to either of the toners to intensify the colors further.

Both copper and blue toners can also be intensified by the addition of potassium bromide (see page 40). Obviously, you can take anything to extremes, and if you overintensify, you will start to see signs of solarization.

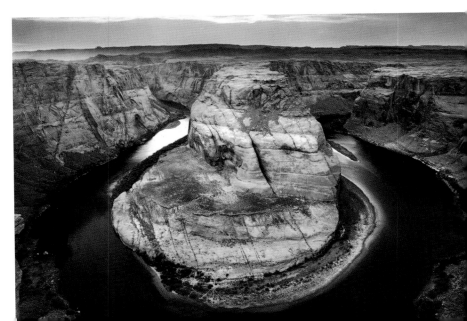

Sepia then copper

If you are doubtful about trying dual toning, then this is one to start with, as the toners are relatively inexpensive and the process is easy to do. The main characteristic is that both the toners warm up your image. It is a process that appears to work on virtually any kind of paper. However, start with a print that is darker and more contrasty than normal, as toning in sepia and copper lightens the tones and decreases contrast.

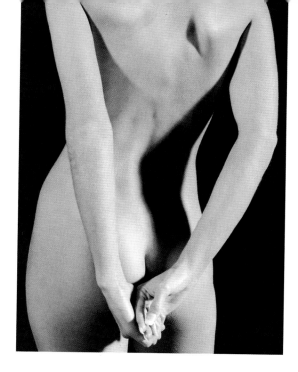

Back and hands
Achieving accurate flesh tones with any single toner can be difficult, but sepia then copper works well. The sepia renders the lightest tones a gentle straw color, while the copper introduces a little more red into the mid tones.

Sneaker (with apologies to Jasper Johns)
As an admirer of Pop Art, I have learned that most everyday things can make useful subjects for a still life. Looking around, I realized that this sneaker had no less artistic merit than the coat hanger in one of my favorite Jasper Johns paintings. So I set about creating this rather painterly backdrop, echoing the work of this artist. Because the background was so much darker than the sneaker, organizing the split between the sepia and copper was child's play.

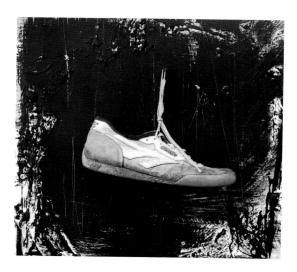

POINTS TO CONSIDER

■ This process lightens your print, so start with a darker image.

■ Both toners produce very warm hues, so pick your subject matter for this technique with care.

AFTER PRE-SOAKING YOUR print, put it in a weakened sepia bleach—be careful that you do not overbleach, otherwise you will have very little silver left for the copper to work on. Once you detect just the slightest color change, remove your print and wash it thoroughly. Then place your print into the sepia toner, and once again use a very weak solution, otherwise the tones of the sepia will be too close to the tones of the copper.

Next, put the print in the copper toner, but this time pay particular attention to the blacks. The lighter tones cannot be toned as they are blocked by the sepia, so you will initially see only the mid tones changing to a red/brown. The color intensity increases the longer you leave the print in the copper, but do not leave it in so long that the blacks lose their richness.

Once you have achieved the desired split, wash your print thoroughly.

Additional controls

If you are working with a contrasty print, it is possible to achieve a triple split. The sepia affects just the lightest tones, while the copper will then start working on the darkest tones. If you remove your print before the copper can start working on the mid tones, then some of them will remain unaffected by either toner.

It is worth experimenting on a range of papers with this technique—it will work on most, and it can do some very interesting things with warm chlorobromide papers. For example, you can achieve some startling, almost solarized, effects with Kentmere Art Classic. If you try this, it is essential that you start with a print that is about 50 percent darker than normal, making sure that you work in all your highlight detail. While the sepia will lighten your print, the effect is dramatically increased when you eventually put it in the copper. Once completed, you should see a rich tan brown in the darker tones, a green/gray in the mid tones, and pale peachy hues in the highlights.

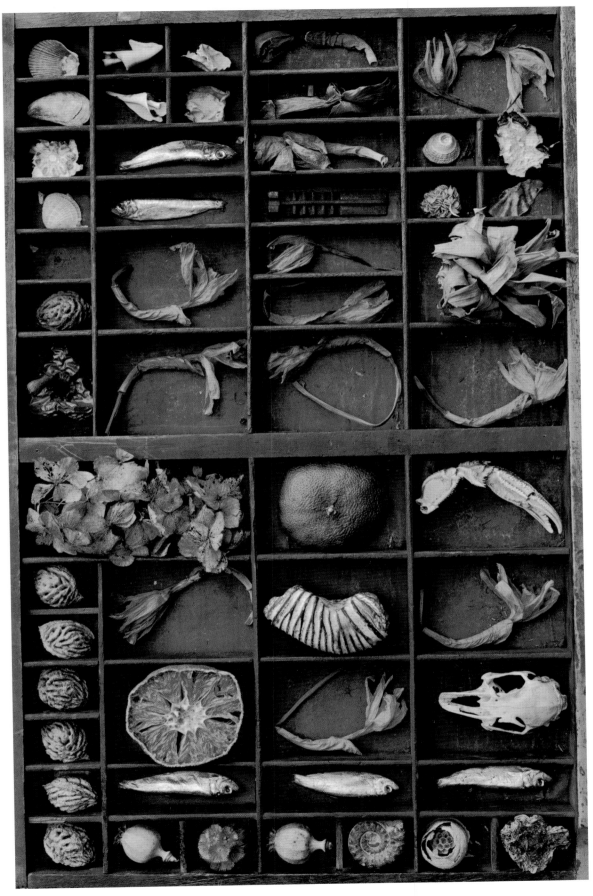

Still life with organic forms

As this process lightens the print, I started with an image that was one stop darker than normal. At the first toning stage, I bleached fairly sparingly so that most of the darker tones remained completely unaffected by the sepia. To further exaggerate the division between the sepia and copper, I used a very light sepia toner. I then copper toned very strongly indeed, while trying to ensure that the deepest blacks were not unduly affected.

Selenium then copper

This is an unusual dual-toning combination that can produce beautiful results with some remarkably interesting colors. Moreover, it is comparatively easy to do. It works well on both RC and FB papers, and if done properly, will archivally enhance your print. As with other dual-toning techniques, however, it does allow enormous scope for personal interpretation depending on the paper/developer combination used, the extent to which you use each of the toner, and the dilution of the solutions.

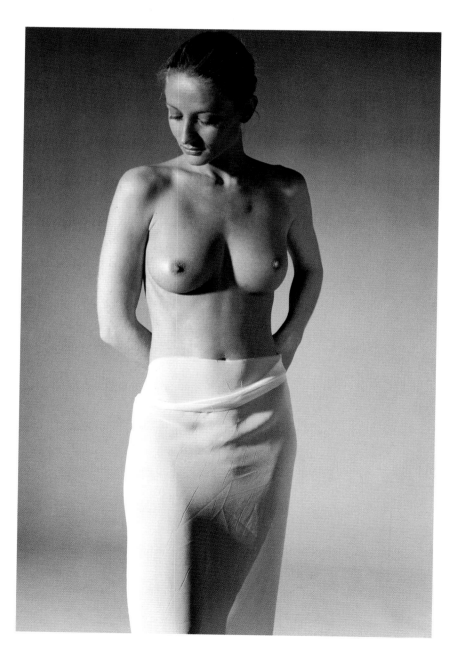

BOTH SELENIUM AND copper toners react quite differently depending on whether the paper is warm or cold. On cooler papers, the areas affected by the selenium will appear relatively unchanged, while the copper will turn the lighter tones pink. Split toning on a warm paper produces particularly interesting results.

The selenium will initially affect only the darkest tones, changing them to a deep rusty red; at the copper-toning stage, the copper appears to affect the lightest tones first and then works towards the mid tones—however, some very interesting results can be achieved when the print is removed before the mid tones are affected, resulting in some beautiful pinks, copper browns, and grays.

Each image reacts differently, and it is important that you conduct your own experiments if you want to predict the results. This again is where test strips prove useful.

The process
1 Always start with the selenium, and then progress to the copper.
2 Place your print in the selenium toner. Different strengths of the solution have different effects on the print, but working with a solution of 1 part selenium to 15 parts of water is a useful starting point. It is possible to see the selenium "travel" from the darkest to the lightest tones, but remove the print just before it has reached the extent of the tones you wish to see affected, and then put it in a tray of clean water.
3 Wash the print thoroughly.
4 Place your print in the copper toner; once

Model looking pensive
This is a particular favorite dual-toning process of mine; it is easy to do and also extends the tonal range of the print. While the selenium works on the darkest tones, the copper lightens the mid tones and highlights.

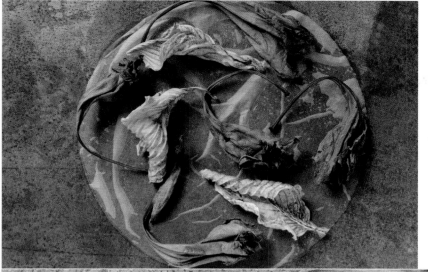

Still life with arum lily leaves

VERSION I (LEFT): This was printed on a cool paper, therefore the areas affected by the selenium appear a cool purple color.

VERSION 2 (BELOW): Personally, I find that the best results are achieved using a warm chlorobromide paper, such as Ilford FB Warmtone, used for this print. The areas affected by the selenium have turned a rich, deep brown, while the areas that are copper toned are rendered an exquisite peach pink and pale gray. This is a wonderful technique for revealing texture.

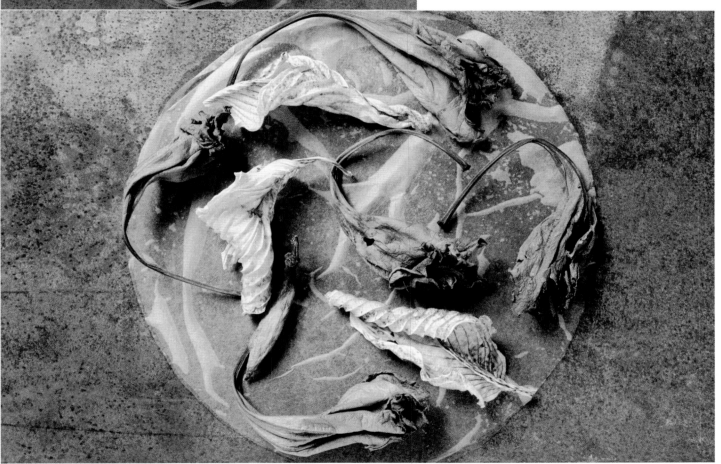

again its strength will have a bearing on the final outcome of the print—the weaker the solution, the more subtle the result will be. Even a weakened solution can work quite quickly, so always have a tray of clean water close at hand.

5 Wash your print thoroughly. Initially, the highlights will appear stained, especially with FB papers, but this will soon disappear.

POINTS TO CONSIDER

■ Always start with the selenium, not the copper.

■ It is a process that works well on either RC or FB paper.

■ The final results can be greatly determined by whether you use warm or cool paper. Warm-toned papers give the most interesting color combinations.

Sepia then gold

Strictly speaking, this is not a true dual-toning technique, as the gold toner serves to change the whole print from a sepia to a vibrant orange, rather than splitting the dark and light tones. However, I find it to be an extremely charming, yet easy, process to carry out. Also, unlike some other processes, dual toning with sepia then gold is a very predictable technique that virtually always produces the anticipated results.

IT IS IMPORTANT to note that this process will not work if you use the gold toner first, so you must always begin with the sepia.

You start off by sepia toning the print as normal, but making sure that you do not overbleach, otherwise you will lose the solid blacks in the print. It is also worth noting that the strength of the sepia toner has an enormous bearing on the final outcome of the print; if you choose to sepia tone your print only lightly, the subsequent gold toning will produce a color that is as near to gold as is possible to get. If, on the other hand, you strongly sepia tone your print, the gold toner will change the print to a rich orange color. My own preferred option is to try to achieve a gold color, although irrespective of whether you lightly or strongly sepia tone your print, the gold-toning stage will always slightly darken the print.

Precautions when toning

In common with all toning processes, it is always best to proceed onto the toning stage immediately after fixing and washing your print. If this is not practical, then you should pre-soak your print for at least 10 minutes, in order to ensure even toning.

On a similar tack, this process will emphasize any bad printing techniques, therefore it is important that your initial print is allowed to develop fully (do not snatch it from the bath too early) and that it is fully fixed.

Model in museum

If you wish to achieve a clear-cut demarcation between lights, darks, and mid tones, dual toning in sepia and then gold is one of the best ways to achieve this. It is important not to over-bleach, otherwise you will lose the solid blacks in the print.

Shop window, Berlin
It is important to
appreciate that you
do have some control
over the final outcome
at this sepia-toning stage.
The stronger you sepia
tone, the deeper the
subsequent gold toning
will be. In this instance,
I have opted for a
stronger-than-average
sepia tone.

- Sepia then gold toning is an easy and usually successful toning process.

- Sepia and gold toning greatly enhances the archival quality of your print.

- Gold toners are relatively expensive and should not be used recklessly.

- You should thoroughly wash your print between the sepia- and gold-toning stages.

It is also extremely important that you fully wash your print after the sepia toning (for up to 30 minutes), as any residual toner in the print can easily pollute the gold toner. When you consider the cost of gold toner, this is a precaution that cannot be overlooked.

The length of time the print spends in the gold toner depends partly on the age of the toner, but also on the required effect you are after. With a very fresh toner, a significant effect can be seen after only several minutes, but if the gold toner has been well used, it may take up to 30 minutes before the required change occurs.

Types of paper

This process works equally well on both RC and FB papers. However, when one pays the high price asked for gold toner, it does seem to be a criminal waste to use it on ordinary RC paper. Moreover, the depth of the toning is much more apparent on FB papers, especially when using the warmer chloro-bromide papers such as Ilford MG FB Warmtone and Kentmere Art Classic.

Suitable subject matter

When using this technique, you should be able to achieve a wide variety of colors, ranging from

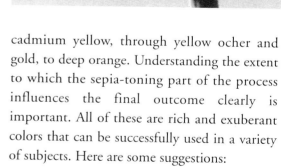

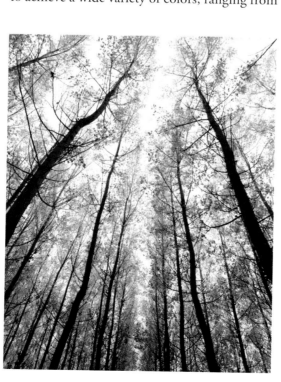

Poplars in Andalusia

VERSION 1: In this example I used a very weak sepia toner and did not allow the print to remain in the gold toner for too long, resulting in these gentle, yet beautiful, golden yellow hues.

cadmium yellow, through yellow ocher and gold, to deep orange. Understanding the extent to which the sepia-toning part of the process influences the final outcome clearly is important. All of these are rich and exuberant colors that can be successfully used in a variety of subjects. Here are some suggestions:

1 They are all terrestrial colors, and they can be suitably used in dry and barren landscapes. You only have to think of such interesting places as Bryce Canyon in Utah to appreciate how effectively this process could be used.

2 Many of these colors can be used to flatter the human form, making the technique useful for black-and-white portraiture. While the lighter cadmium yellow might possibly pose problems, skin can look particularly appealing when toned a golden brown.

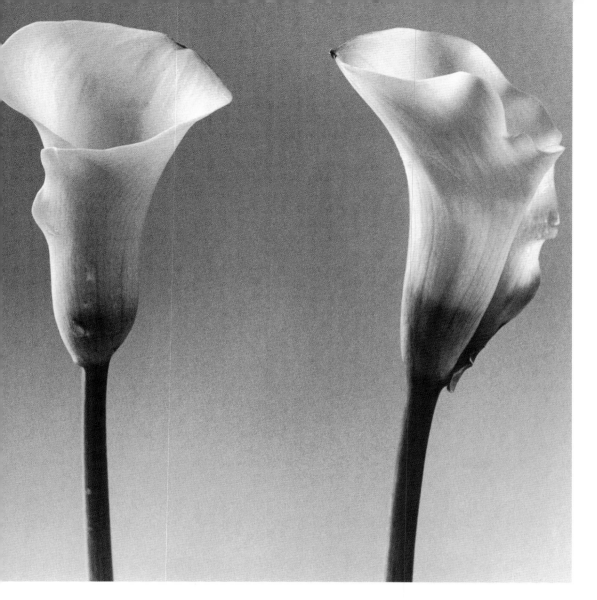

Lilies
When dual toning with sepia and gold, you are able to achieve a golden hue ranging from a very light brass color to a deep orange. This is determined by how strongly you sepia tone your print.

3 Possibly most obviously, these colors are clearly linked to Fall and, therefore, can easily be exploited within a landscape context to suggest blazing foliage. These colors are even reflected in the fruits of Fall, and one has only to think of such fruits as oranges, mangoes, persimmons, peaches, and pumpkins to appreciate just how prevalent these colors are.

This is not intended to be a definitive list, as the opportunities do appear to be endless. When you consider the many other advantages of toning in sepia then gold, this is a technique that is well worth exploring.

Poplars in Andalusia

VERSION 2 (RIGHT): In this example, I sepia toned far more noticeably than in the shot opposite, and I also left the print in the gold toner for longer.

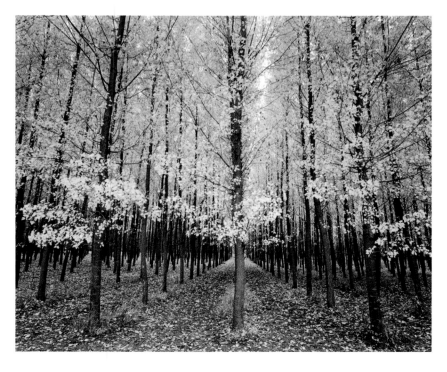

Selective toning

Selective toning is a technique in which only part of the print is subjected to the toning process, thus leaving the other areas untouched. This is normally achieved by masking the areas you wish to remain unaltered by the toner. It is a technique that is ignored by many photographers, partly because it is thought of as being difficult to do—but also because, if done badly, it can appear rather tacky. To the casual observer, selectively toned prints can look very much like handtinted prints, but there are several important distinctions.

ONE OF THE main advantages selective toning has over handtinting is that it is easier to retain your highlights. The toner merely changes the color of the print, without drastically altering the relative tones within the print. Also, selective toning is more durable. While some handtinting methods are archival, not all are; and even those that are can be extremely vulnerable to finger marks.

However, there are several limitations with the selective toning process. First, you are restricted by the colors available for toning. Another restriction is that it is very difficult to gradate one color into another when selectively toning. If you are handtinting, blending one color into another is relatively easy. Increasingly I find that using the benefits of selective toning in conjunction with some

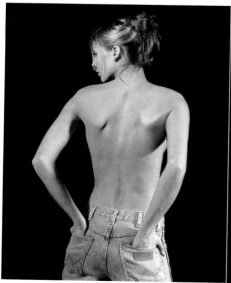

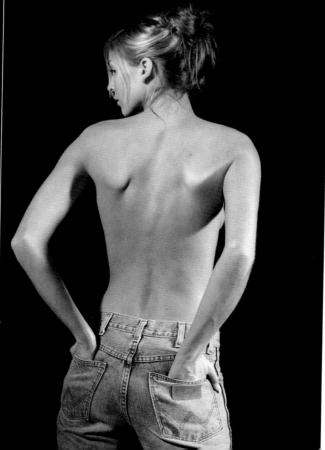

Wranglers I
When choosing the untoned print, it is important that you ensure that all the tonal detail is printed in prior to toning.

Wranglers 2
The entire print was toned in a weak sepia solution. A mask was then cut (above) covering all the image except for the jeans. The print was then put in a blue toner that only affected the exposed areas.

Paintbrush

There is no need to use complicated masks when selectively toning. Here, I toned the entire print sepia and then applied undiluted copper toner onto parts of the brush.

limited hand-tinting can prove to be the most appropriate technique for many images.

Selective toning can be achieved in one of two different ways:

I Apply the toner by brush. By skillfully painting the toner directly onto the print, you are able to control which areas are toned with relative ease. In my experience this works well for relatively small areas but is much more difficult to achieve with larger ones. When using a brush, apply toners undiluted. Use watercolor brushes and apply the toner carefully, and be prepared to douse the print in a tray of clean water once the critical stage has been reached.

2 Alternatively, you can use masks. In this way it is possible to tone the entire print in a normally diluted toner, that will only work on the exposed, unmasked areas.

Masking can be achieved by using masking fluid. This is a rubber solution that can be bought in most craft stores. You apply the solution directly onto your print in those areas

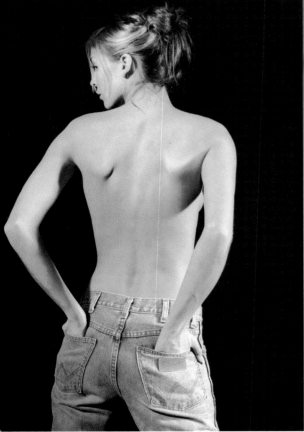

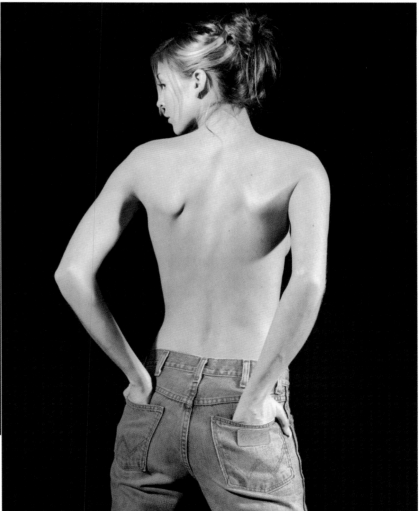

Wranglers 3

In this print only the jeans were masked with masking film (right), and then the print was dual toned, first in sepia and then in copper, in order to achieve plausible flesh tones. The jeans remain unaffected.

Wranglers 4

With the jeans masked, the print was dual toned in sepia then copper. The mask was removed and a new mask cut to protect the toned areas. The print was then toned blue. If an area bleeds unexpectedly, save the situation by painting in undiluted paper developer.

African cones

The entire print was sepia toned, then the cones were selectively worked on with undiluted copper toner, using an artist's brush. If you selectively tone larger areas in this way, restrict yourself to natural forms.

that you wish to remain unaffected by the toner, although it does need to be applied with a care. The fluid is usually colored, so it is easy to see which areas you have covered. It works best on small, irregular areas.

Alternatively, you can use commercially made masking film that should be available from most art stores. Masking film is a low-tack, transparent, soft-peel product that has been designed specifically for masking areas from airbrush work, and it can also prove to be an indispensable aid when selectively toning. Masking film is normally manufactured and sold in rolls, and you simply cut off what you need to use at any one time.

The masking process

Place your print on a flat surface, but make sure that there is no grit or debris on it. Carefully peel the masking film from the backing paper and lay it over the print, working from one end to the other. If you have trapped any air bubbles, carefully lift the film from one end and release them, and if that fails, simply remove it completely and then reposition it.

Using a scalpel, cut away the film in those areas you wish to tone. Some people are worried about cutting into the surface of the print, yet ironically, the sharper the blade, the less likely you are to damage it, providing you use minimum pressure. Use matte or pearl papers,

because if you are unlucky enough to nick your print, then it is less likely to show. Once you have cut around all the areas you wish to tone, carefully peel away the film. It is very important that you check all the cut edges at this stage to ensure that the film has not lifted. Carefully press down all edges, just in case. At this point you are ready to start toning.

Once you have gained sufficient experience of selectively toning with one or two toners, it should be possible to use more. Remember that you are not dual toning, so you can use virtually any combination of toners, providing your paper is compatible.

There is, of course, a downside: the more masks that you use, the more likely you are to nick your print. Similarly, it is easy to make mistakes when putting on the masking film, which could allow bleeding. This would prove particularly annoying if it was the last of a sequence of six separate color tones.

Finally, this is an excellent technique to use with a print you wish to dual tone but, because of the distribution of the tones, will not behave the way you wish it to. By using a mask, this can be easily achieved. There is no reason why you cannot tone the entire image and then selectively tone parts of it; once you have appreciated the principle, the sky is the limit.

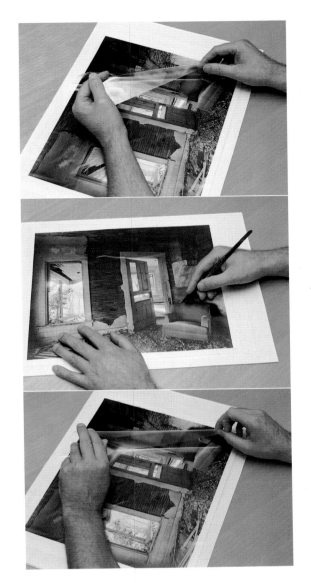

Using masking film
Carefully place the film over the entire print.

Cut through the film with a scapel and remove the area that exposes the part you want to tone.

Once toning is complete and the image is dry, peel off the masking film.

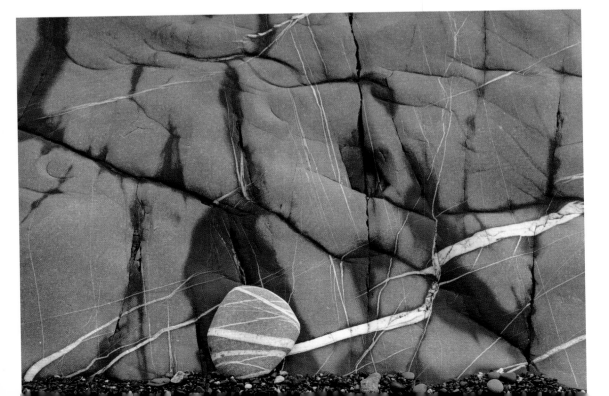

Foreign import
The pebble has been masked with film, while the rest of the print was toned blue. It is very important that you check that there are no air bubbles trapped under the masking film through which the toner can seep.

Lith printing

Lith printing is a particularly broad subject, and it is very difficult to do it justice in just a few pages. But it is a technique that can open so many other opportunities, both in terms of toning and dual toning, and if we were to ignore it then we would not have a full appreciation of what can be achieved through toning.

THE BASIC LITH process works as follows: you grossly overexpose your printing paper, and then develop it in a very diluted form of a special lith developer. This triggers a process known as "infectious development." When you process a print in an ordinary developer, it takes just 1 or 2 minutes before the print is fully developed, and then the development stops.

When processing with lith, development is incremental—it starts off very slowly but increases in pace, until finally it is almost uncontrollable. If you do not remove your print from the lith developer in time, it will eventually turn completely black.

As long as you are prepared to proceed with great care when using lith developer, you will be rewarded with stunning prints. The hallmark of the lith print is strong shadow detail and fine, delicate highlights. Irrespective of the wonderful colors that can be achieved at the toning stage, this contrast can be reward enough.

What papers do I need?
In principle, all warm chlorobromide papers

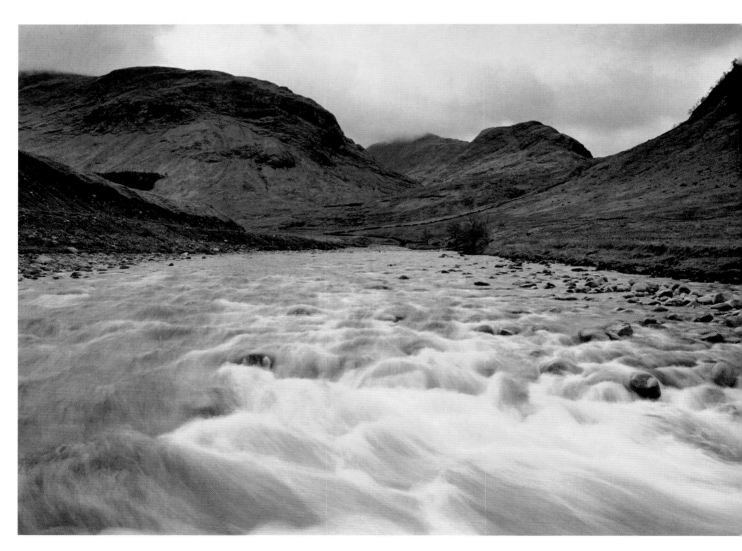

should work, but not all do in reality. Kentmere Kentona is a wonderful paper that responds particularly well to lith. If you can get hold of the original Kentona, expect to see some remarkable colors even before toning, ranging from delicate pinks to powerful reds. The newer, cadmium-free Kentona is less interesting but comes into its own when toned either in selenium or gold. Kentmere Art Classic has a fine-textured surface not unlike watercolor paper. Fotospeed Tapestry has a more pronounced texture than Art Classic, and again responds well to gold and selenium toning.

Kodak Transtar TP5 Paper is one of very few RC papers that respond well to the lith process, so if you wish to tone or split tone, this paper is far easier to use than most. Fotospeed Lith is a semi-glossy FB paper designed specifically for lith, but it is also excellent with conventional paper developers. Oriental Seagull G is a double-weight FB paper classic that is excellent when used conventionally, or with lith.

Lith developers

While some conventional papers can be used for lith printing, you do need to buy a specialist lith developer for this process to work. Fotospeed LD20 is widely available and very much the standard lith developer. It comes in liquid form, parts A and B, as does Kodalith Liquid Concentrate Developer. Kodalith Super RT Developer comes in powder to mix parts A and B. Unlike other lith developers, Speedibrews Lithoprint Developer is a single solution developer that comes in powder form.

Suggested precautions

Lith is a particularly fickle process, unforgiving

River Etive

VERSION 1 (FACING PAGE): Printed on older-style, cadmium-rich Kentmere Kentona paper, the image was briefly toned in selenium. As it started to change, first to brown and then to gray, the print was removed and placed in a wash bath.

VERSION 2 (BELOW): This example has been dual toned in selenium and then gold toner. The colors are much cooler, but the results are equally as interesting.

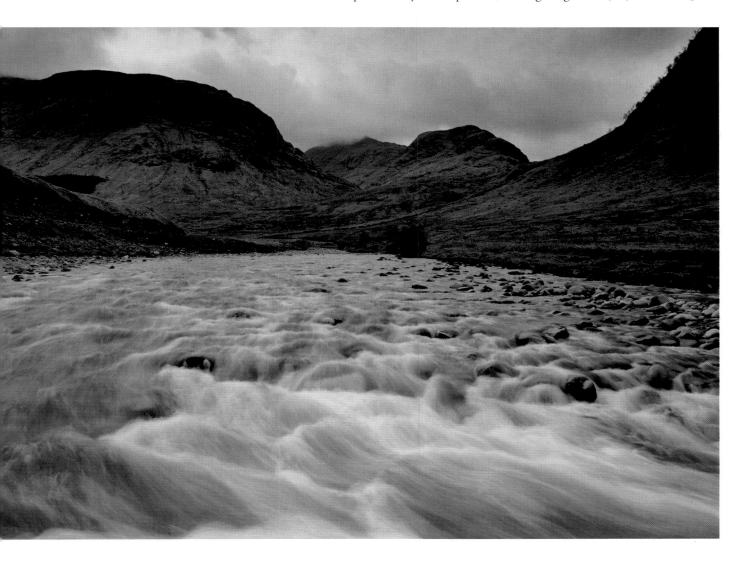

of poor darkroom technique. The most likely cause of spoiled prints are finger marks, so wear latex gloves when handling paper. Use a decent pair of tongs to avoid handling prints.

When processing, give your print space, otherwise marks will appear on the edges of the paper. Always use developing trays that are the next size up from the size of the paper.

Exposures and processing times are considerably longer with lith printing, so ensure your darkroom really is lightproof and that your safelight is at a distance from your working area.

Preparing the developer

Most lith developers come as an A and B solution. Begin by following the manufacturers' instructions for mixing, then, as you become more confident, experiment with different dilutions and you will discover that many different results can be achieved.

All developers improve as they mature, and this is particularly noticeable with lith. To promote maturity, when you start printing use a small amount of used lith developer from a previous printing session.

As a rule of thumb, add as much of this "old brown" as you do of the undiluted solutions A and B. If you add 6fl oz (100ml) of A and 6fl oz (100ml) of B to 56fl oz (2 litres) of water, then add 12fl oz (200ml) of "old brown" to the newly mixed developer. For a lengthy printing session, have a jug of mixed solutions A and B ready, as the effectiveness of the developer can suddenly peter out in the middle of processing.

Exposing your paper

When working with lith, you can expect to triple the usual exposure time of 10 to 30 seconds—it is not unusual to have a general

Kate seen in profile
This print has been lith printed onto Sterling paper but not toned. Many find the warm, peachy hues of this paper particularly suited to portraiture.

exposure of 5 or 6 minutes, even with a wide aperture. The grade of paper you use when lith printing seems to have very little meaning, as the longer you expose the paper, the less contrasty the final print will become. You are not "overexposing," merely reducing the contrast of your print. The big plus is that there is often very little need to burn in highlights, although you may be required to hold back some shadow detail. It is essential that you follow this simple rule: expose for the highlights, develop for your shadows.

The role of the test strip

Test strips are especially valuable when using lith. Some lith practitioners suggest that you can make a test strip using a conventional paper developer and then multiply the exposure by a factor of 2 or 3. This requires having to mix up 2 separate paper developers, and while you are able to establish the correct exposure time in this way, you can't make an accurate contrast assessment. Finally, it is always useful to have your test strips so that you can do further tests at the toning stage.

Developing your print

As the image slowly starts to emerge, darkest tones first, gently agitate your developer to coax out the rest of the tones. Development is very slow at the early stages, but it quickens toward the end of the development and you have only crucial seconds to decide whether to remove your print: too early and your print will be too light, but a few seconds later it can be too dark. Keep a stop bath available to arrest further development, but don't make it too strong or the print will stain.

Pepper fogging

Pepper fogging refers to the appearance of small black dots across your print. Often it is just 3 or 4 marks, but, irritatingly, they are always in key areas. It is caused by the oxidation of the hydroquinone in the developer, and the answer is to add either a small amount of sodium sulphite or potassium bromide to your lith

developer (sometimes you need to add both). Fotospeed very kindly add sachets of both chemicals with their lith developer kit, so follow their instructions.

Fixing and washing your print

Fix your print as normal, although do not be surprised when your mid tones lighten dramatically, as this is another common characteristic of lith. If you intend toning your print (and really this is where lith starts to become interesting), then make sure you use a non-hardening fix. When you've finished, your print will have assumed a very warm color, ranging from sepia to brick red, depending on the paper and process. Thoroughly wash your print, because even the slightest trace of fix will ruin it, showing up dramatically should you choose to tone.

Torso

This image has been printed onto the old, cadmium rich Kentmere Kentona paper that produces this characteristic brick-red color.

Antelope canyon

(OPPOSITE) This image has been printed onto Kentmere Kentona paper, and then dual-toned—firstly in selenium and then in gold, producing these wonderful rich browns and delicate blues. The fascination of lith printing is that it offers the printer considerable scope for personal interpretation.

Toning lith prints

Some may wonder whether there is any need to tone a lith print, as the process itself produces interesting colors. If you are using Fotospeed Lith, expect to achieve a rather attractive warm beige. However, if you use Fotospeed Tapestry, then the overall hue is slightly pinker. With Kodak Transtar TP5, you can achieve a pink/red without further toning, but these "warm" emulsions are noticeably responsive to toning, particularly to toners (notably gold and selenium) that produce only limited color changes on conventionally produced prints.

Toning lith prints in gold

Gold toning increases the archival qualities of a print and is capable of producing a subtle blue/black, especially with warm chlorobromide papers. The effect is dramatically increased with lith prints, and you should be capable of producing a vibrant blue with some papers.

The color of the print may initially be very warm, so it will need to go through a number of color changes before you achieve blue. You can open up new opportunities by removing your print at any time during the toning stage.

Each paper responds slightly differently. A paper such as Art Classic will change to mauve, through purple and blue. Fotospeed Lith, on the other hand, will turn a cool gray before gradually changing to blue. These changes are not uniform, as the darker and lighter areas of the print are affected by the toner at different rates, and if you remove your print during one of these interesting transitions you can achieve beautiful results.

Finally, while iron blue toners are attractive and easy to use, the prints may not last very long, so if you want to produce vibrant blue prints that are archival, then lith might be the best approach.

Lith toning in selenium

This, once again, is where lith becomes interesting, as the selenium tries to change the print into a rich brown but has to go through a variety of color changes to get there.

With Fotospeed Lith, expect your print to change to a warm red/brown, before going to a cool gray then a brown. Fotospeed Tapestry, meanwhile, can start out beige but then change from pale lilac to blue and eventually to brown. Just like the gold toner, the color transitions in selenium are not uniform, as parts of the print respond differently depending on the print density, and the secret is to exploit this.

Split toning with selenium then gold

This technique involves the trials and tribulations of lith printing, but when you finally succeed, the results can be stunning. Selenium and gold are two of the most stable toners, so providing you have processed your print with care, you can expect it to last for a lifetime. This technique works well with most prints, irrespective of the tonal range.

Start with the selenium toner; the dilution will affect the speed of the process. I generally use 1 part selenium to 15 parts of water, so there is a slow color change. The print will start to go through the color-changing process, depending on what paper you are using. You will notice the selenium initially having a positive effect on the darkest areas of the print.

Keep a close eye on this transformation, and make a judgment as to when to remove your print from the selenium bath. Have a tray of water available so that you can stop the process precisely when you want to.

Wash the print thoroughly before the gold-toning stage, as even a smallest trace of selenium will pollute the gold toner and reduce its effectiveness. I would recommended you wash the print for at least 30 minutes at 68°F (20°C)—even longer if your water is colder.

Once washed, put the print into the gold toner. The speed of gold toning depends on how fresh the toner is, it may take only a few minutes, but it could take up to 30 minutes. It is easy to overtone with the gold, and as the blue dries this becomes more apparent. If all goes well, you will be rewarded with rich blacks and browns in the shadows and delicate blues and blue/greens in the highlights.

Toning with tea and coffee

Toning photographs with tea and coffee may seem to be a rather quirky thing to do but, rather surprisingly, it does work. Some may question the longevity of the resulting prints, and I am not in a position to give any definitive answers. However, the tea stains I got on my white shirt while doing this section still have not come out, despite numerous washes and a soak in an enzyme detergent. So, let us just say that I am quietly optimistic!

COFFEE AND TEA are not, of course, designed as toners, so do not expect them to behave as such. Chemically, they neither attach themselves to nor change the silver in the print. They merely stain the print and cannot distinguish between different tones.

In effect, toning in coffee or tea colors the highlights to the same extent as it does the dark tones, thereby reducing contrast; it can do this quite severely, depending on how long you tone for. Choose the right subject, otherwise your print could end up looking rather flat. The technique works well with portraiture, partially because the colors you are able to achieve are very similar to certain skin types. In order to add extra emphasis to the eyes, try masking out the whites of the eyes with masking fluid; the results can be electrifying.

It can also work well with landscapes or architectural shots, giving the impression that they were taken at dawn or dusk. Once again, you may look for opportunities for very restricted masking. It is important that you print just a little lighter than normal, as this process gradually darkens the print, and try to ensure that there is some detail in the highlights, otherwise they can look unreasonably flat.

The process
Try not to handle your print too much, because if you leave finger marks on it, then the oils they contain tend to act as a resist to the staining process. The technique seems to work far better on FB papers than on RC ones, as the plastic in the latter seems to act as a barrier. It does not seem to matter whether you are using a warm-

Woman with veil
This print has been toned in a normally brewed, and slightly warm, solution of tea for 15 minutes. The white of the eyes has been retained by applying masking fluid beforehand.

The gaze
This works quite well as a straight black-and-white print, and initially I was quite reluctant to tone it in either tea or coffee. However, I decided to tone it in a normally brewed, and slightly warm, solution of tea for 15 minutes to bring color and warmth to the image.

or cool-tone paper, as the tea or coffee simply stains what is there.

The process works cumulatively, so the longer you leave your print in the tea or coffee, the richer the color becomes. To get a satisfactory color you will need to tone for at least 15 minutes. I have not done exhaustive tests with this process, but one brand of tea, or coffee, seems very much the same as another. The strength will obviously have some bearing, but I tend to use the usual brew one would normally expect to drink. As a toner, it does tire easily, and I find that I need to mix up a fresh brew for each print. It is not necessary to agitate the print continually, but if you do not agitate from time to time, the toning can be rather patchy.

You can speed the process up by warming the toner; do not go over 95°F (35°C), otherwise you risk harming the emulsion. However, if you wish to protect an area, masking fluid will only stay on if the temperature of the toner is no more than lukewarm.

Finally, tea and coffee will tone everything, including the white border—so if the border is important to you, then you may have to consider masking it with film.

PART THREE
HAND-COLORING

Handtinting monochrome images has become increasingly popular over recent years. I suspect that this is largely because photographers wish to introduce a "handicraft" feel to their photographs—a quality that digital imaging cannot possibly provide. It is as if digital imaging has become too perfect and some printers crave that natural imperfection of anything that is done by hand. Many photographers, in addition, use hand-coloring as a way of discovering the hidden artist within them.

Fish with spanners
A very restricted amount of handtinting has been applied to this image. However, by using two complementary colors (blue and orange) in close proximity, the print is given the illusion of being more colorful than it really is.

Introduction to handcoloring

THERE ARE MANY different ways to handtint photographs. But while each of the handcoloring processes we will be covering in this chapter has its own unique characteristics, there are various issues, and rules of thumb that underpin them all:

1 Try not to handcolor your work in a visual vacuum, otherwise your results can end up looking too unrealistic. While one of the undoubted pleasures of handtinting is that you can choose what colors to use, it is an advantage to have some awareness of how different colors work together.

Familiarize yourself with important visual phenomenons, such as "local color." This suggests that any color will have an influence on those colors around it. For example, if you place a shiny blue car alongside a bright red telephone booth, then something of the red will appear in the blue car, while some of the blue will be reflected in the telephone booth. A much more typical example of this can be seen in landscapes featuring dramatic skies; if the sky is predominantly red, then it will permeate throughout the rest of the landscape, even the green foliage. As the sky is the source of light, then it will affect all other areas. When toning and then tinting, be aware of these visual phenomena, and employ your colors with care.

2 A useful way of learning how to apply your color meaningfully is to keep a scrapbook of colored images and use them as points of reference. I occasionally use a compact camera to "sketch" situations, and then refer to the prints for important elements of detail. You may well ask why I do not

just produce a color enlargement and have done with it. But the important point is that through handtinting I can be eclectic about what I use, rejecting some colors and mimicking other combinations.

With some subjects, such as still-life shots of fruit, you can refer to the object itself to refamiliarize yourself with the subtlety of the natural coloring.

3 Try always to work under natural lighting. The major advantage of handtinting is that you do not need to be restricted to the darkroom. Colors do look different in daylight, so try to use it wherever possible.

4 On a similar tack, handtinting can be a time-consuming activity, so make sure that you are working in an environment that you find comfortable.

5 Use toning, or dual toning, as a major part of your handtinting process. Starting from a purely black-and-white print is truly formidable—and while you can produce excellent

handtinted images in this way, why make things difficult for yourself? Much of the groundwork can be done using toning.

6 Avoid overcoloring your work. When young children paint, they tend to use every color available, and while their work has undoubted charm, it can often lack visual cohesion. Use a restricted palette, and selectively color the print.

7 Try and acquaint yourself with as many different handtinting techniques as possible, as they are all uniquely different. One of the most satisfying things we can achieve with our photography is a personal style, and this is so easily achieved through handtinting. It is almost inconceivable that you will not find at least one technique in which you will excel, providing you are prepared to work patiently.

8 Give yourself time! Do not expect immediate success, and if time is running out, don't rush to finish; remember, there is always another day. Aim to succeed, and when you do, your appetite will be whetted for more ambitious projects.

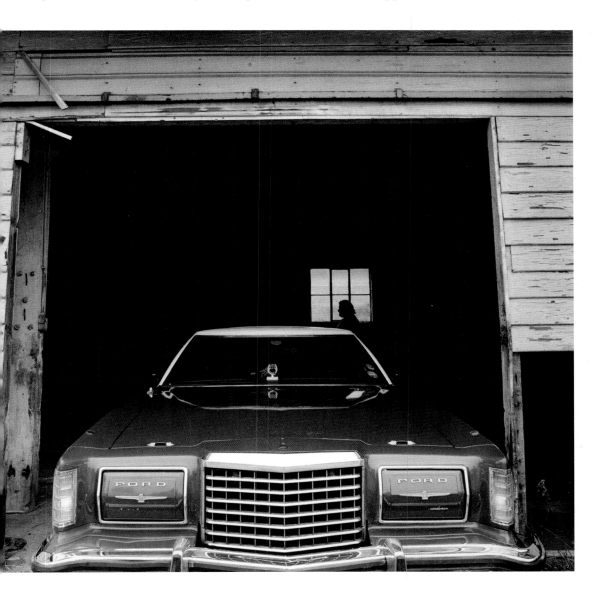

Pier, Lytham St Annes

(FAR LEFT) The entire print was toned blue, and then a mask was cut to protect the parts of the building that project above the horizon. Then the sky was airbrushed just above the horizon, first yellow and then red. Imagination is a wonderful thing, and as soon as even a small amount of color is introduced, the mind can begin to read this as a color picture.

Thunderbird

Any image will always look convincingly colorful the moment you have all three primaries present. Once this print was sepia toned, I introduced the smallest amount of red and blue in the area of sky visible through the garage window.

Understanding color

Often with conventionally produced color photography, one or more elements will serve to distract the eye, because its color draws attention to it. But with handtinting you have absolute control and can produce images that combine perception and imagination. But it is important to understand how color works and to ensure that it remains an accurate vehicle for your thoughts and emotions.

COLOR IS A strange visual phenomenon. It is all-pervasive and can so easily be taken for granted. As we are able to exercise so much control when handtinting, it is important that we are aware of what various colors can do for pictures—how they interact with one another, and how they are perceived by the viewer.

Red, orange, cadmium yellow, and brown, for example, are seen as warm colors, and collectively they can produce a predictable visual response. Blue, green, gray, and lemon yellow, on the other hand, are cool colors and promote an entirely different reaction. It is important to think quite carefully about the psychological effect that color can have, particularly when combined.

Another equally important issue is how to mix colors. In photographic terms there are three primary colors, namely magenta, cyan, and yellow; but as soon as we begin to deal with paints and dyes, then the three primary colors are red, yellow, and blue. These are the building blocks of color mixing, and all other colors can be made up from them. For example:

- red and yellow make orange
- red and blue make purple
- blue and yellow make green
- red, yellow, and blue make brown

Mixing colors for mood

When you choose colors for handtinting, think carefully about the mood you are trying to convey. With some subjects, strong contrasts are particularly effective, while in others much quieter, more harmonious combinations are required. When deciding the mood you wish to create, it can be helpful to study photos you particularly admire and analyze the color content relative to the color wheel. In this way you will quickly appreciate how colors work, and which combine well together.

The Color Wheel

The color wheel is a means of explaining how various colors relate to one another. Without stating the obvious, colors are either similar to one another, or they are distinctly different. Those that share the same primary color will inevitably be similar, and therefore will harmonize. For example, orange and brown work together well because they share the common primary color yellow. Orange also harmonizes with red because it is next to it on the color wheel.

The color opposite orange on the color wheel is blue, so blue is the color that is most unlike orange—these two colors are considered to be "complementary" to one another.

Having a good grasp of how colors interact with one another is an indispensable aid to handtinting. If you wish to see a strong contrast in your image, for example, you should aim to use complementary colors. Thus the best way to make a blue element in a handcolored photograph really stand out is to surround it with orange.

Primary

Secondary

Secondary

Primary

Primary

Secondary

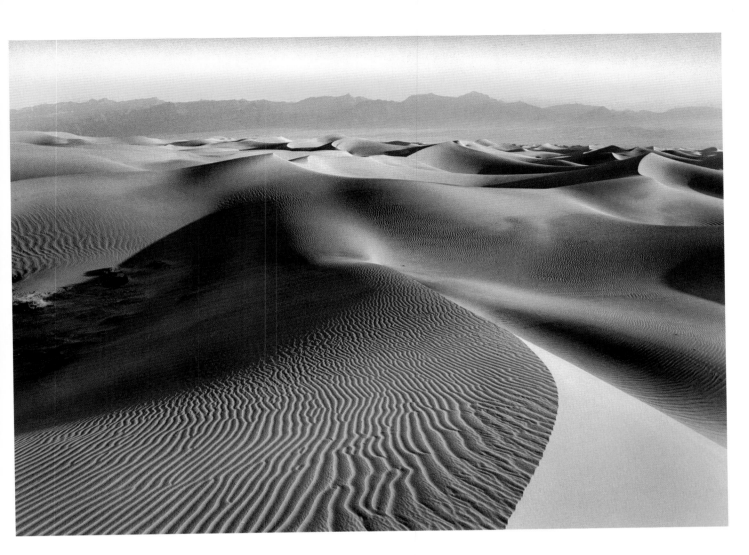

Death Valley

This black-and-white photograph was sepia toned before I began handcoloring. Although only a relatively small amount of pigment has been added to the sky, the print has been transformed into a "color" photograph. I allowed the colors to bleed into the horizon, in order to make the technique less obvious. At the printing stage, the middle area was held back marginally so as to retain important shadow detail, and I worked to maintain highlight detail and make the highlights in the ripples white.

Coca-Cola machine

While traveling in Montana I came across this abandoned community. It was visually bereft except for a discarded vending machine. By strongly sepia toning the image, the dry and arid nature of the land is enhanced. The horizon and the machine were handcolored using an airbrush. The smaller details, especially on the machine, were added using Marshall's oil pencils. It was critical that I got the color detail of the Coca-Cola machine absolutely correct, so I took another photograph with a compact camera, loaded with color film, and used that print as a reference.

Picking out small detail

I made it quite clear in the Introduction that I have no wish to intimidate you with skills you feel you are unable to do yourself. Toning and dual toning are procedural techniques, and providing you work with care, you should be able to master them. With handtinting, however, you will need to develop fundamental skills. There is no need to be fazed by this, but you should learn to walk before you can run. Therefore, when you open your first box of dyes or oils, do not use them all. Instead, be as sparing as possible, using just two or three colors in a restricted area.

Most photographers who work in color would give their eyeteeth for the opportunity to photograph a monochrome world, where only selected objects were in full color, particularly if they could choose these objects and their colors.

As a teacher of art, I frequently see students experimenting with paints; surprisingly, the more restricted the palette used, the more successful the images become. Imagine that you are walking down a busy street, bedecked with colorful signs, flashing lights, bunting, gaudily dressed people, and store window displays each trying to catch your eye. Seeing so many different colors might prove to be uplifting, but visually it would be confusing, making it very difficult to concentrate on any single part.

Learn to appreciate and applaud simplicity! Not only will you find it far easier to manage, but you will also end up with images that hold together far better.

Green Chair

VERSION 1: An untoned print that has not been handtinted. As the negative was relatively thin, the print is rather dark.

VERSION 2: This version of the photograph has been lith printed. Notice that while I have been able establish certain key dark areas, the overall print is much lighter than the conventionally produced print—this is one of the principal controls you have with lith. The print was then toned in a weak solution of selenium, giving rise to the browns, pinks, and grays. I wanted to draw particular attention to the fabric of the chair, so I decided to handtint it using photo dyes. While I wanted to draw the eye, I was anxious that the color used was not too flamboyant. The opposite (or complementary) color to the background would have been a bright yellow/green. However, that would have been just a bit too strong, so I opted for a duller green. When dealing with such a restricted area of color, it is important to get the color right.

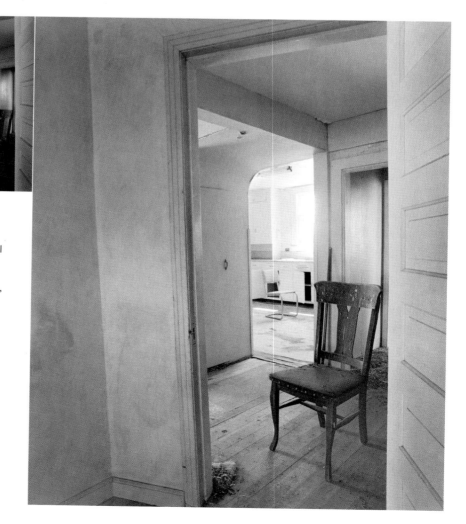

Near Langdon, North Dakota

This print was taken from a negative that remained untouched for about 14 months, until, by chance, I read that the town of Langdon holds the record for being the coldest place in mainland America. The photograph was taken in the middle of August, but by lith printing the image and then toning it in selenium and then gold, a much colder atmosphere is created. I then picked out the rusty, bullet-ridden metal canister with photo dyes.

Working with a restricted palette clearly requires getting it right, and an inappropriate color combination will very easily show. You need to think carefully about how you tone your print, and then consider what effect an additional color will have. If you want your selected area to blend in with the rest of the picture, choose a color that reflects the background. If, on the other hand, you wish to introduce an element of contrast, pick out a color that is complementary. Once you realize that you have a control over these decisions, handtinting really will become quite addictive.

Hi-Way Service and Groceries

Handtinting a black-and-white print from scratch is quite demanding in terms of time and effort, but by toning or dual toning the image first you will have a background color to work with. This shot has been dual toned, first in sepia and then in blue, so only the billboard required tinting.

Photo dyes

Photo dyes are an easy, effective and accessible way of coloring black-and-white photographs. The results are permanent, and by working in layers, you can achieve the wonderfully luminous results that are very much the hallmark of this technique.

PHOTO DYES ARE one of the most popular routes into handtinting—and there is a surprising range of different kits that can be bought. These include:

■ Fotodyes from Fotospeed are a very useful start to handtinting, if for no other reason than they will replace individual colors. The kit comes with 11 colors and the reducing agent. You are able to mix these colors together and should be able to get any required hue.

■ Photocolor's Color Dye Set is very similar to Fotospeed's. It also comes complete with a reducing agent.

■ Paterson's Retouching Kit comes with 11 colors plus 2 whites. However, I would try not to use the whites, other than for spotting.

■ Jessops' Mastertouch Pic-Fix is the only one to supply the colors as solid tablets (rather than in liquid form). The manufacturer claims the product is lightfast, but you do need to do a fair amount of mixing before you get the color you are after.

■ Kodak E6 Dyes were designed for spotting color transparencies and, therefore, come in only three colors: cyan, yellow, and magenta. Photographically speaking, these are the three "primaries," so you should be able to mix virtually any other color from them. In reality, though, it is much more difficult than using red, yellow, and blue. Since they have been designed for spotting transparencies, there should be no doubting their light fastness.

■ If you are looking for a much cheaper alternative, then you may care to try food dyes. These can be easily bought from supermarkets, and are as easy to use as conventional photo dyes. They are not, however, lightfast.

Best paper surface

Surprisingly, photo dyes seem to work on all types of photographic paper, largely because they are capable of being absorbed directly into the gelatin of the emulsion, which is one of the reasons this is proving to be such a highly popular method of handtinting photographs. They are perhaps just a little harder to use on glossy papers, but there is no need to be put off if that is the only paper you use.

Most subjects will work with the technique, although try not to be overambitious straight

Two tulips

This image was partially sepia toned in order to retain some of the blacks. Then it was handtinted using Fotodyes.

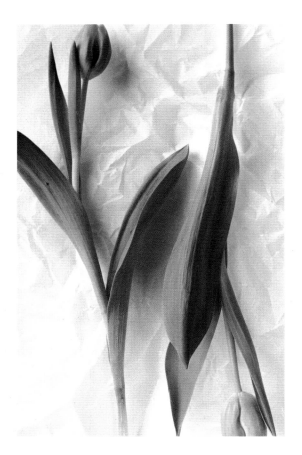

Sara

Many inexperienced workers hit problems when they attempt larger areas, such as the background in this picture, but these can be successfully done, providing you are prepared to build up your color using thin washes. Mix up more color than you require, and ensure that the working surface of the print always remains damp.

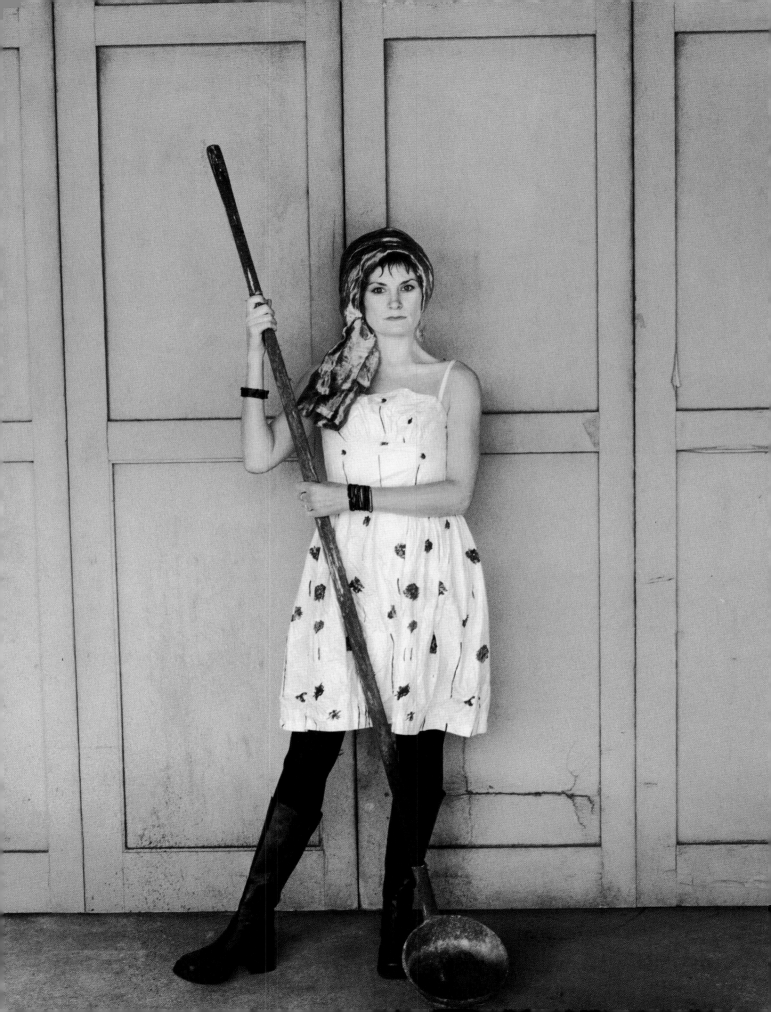

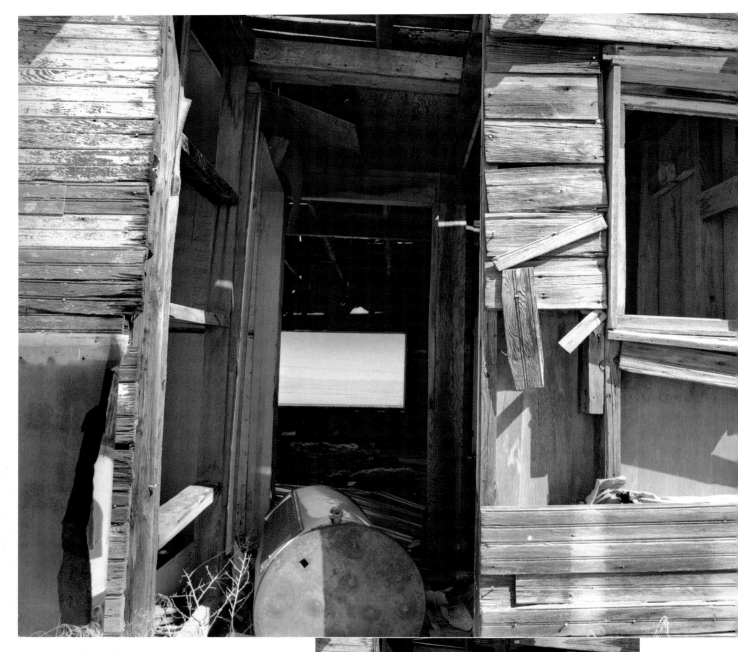

Building damaged by the elements

VERSION 1 (RIGHT): There are many occasions when an image, seen purely in black and white, can appear rather confusing.

VERSION 2 (ABOVE): Once color is added, there is an increased sense of dimension and clarity.

away. Make sure that you do not have any bald, white areas in your print, as the technique can very easily show. Also, while high-key pictures can look quite magnificent when tinted with photo dyes, dark, low-key images are far easier to learn on. Finally, try to choose a subject that best illustrates this medium and its capacity to create deep, rich, translucent colors.

The process

Print your picture just a tad lighter than your anticipated final result, as the tinting will serve to darken it. Tape your print onto a smooth, flat surface, ensuring that there is no grit or debris present. Then dampen the areas you want to work; there is no need to wet the whole print, but never start working on a completely dry area, otherwise you will experience streaking.

This is a relatively straightforward process, but make sure that you have a clean paint palette at hand (a dinner plate works extremely well), and a jar of distilled water. You will also need a selection of good quality watercolor brushes (sable if you can afford them), ideally ranging from size 1 to 8. Do not compromise, as only good-quality watercolor brushes can soak up the pigment effectively.

Mix your color with care, testing it on a spare piece of paper to ensure that it is accurate. Also, make sure that your color is thinner than you think you need, as the process is all about building up washes. Add a small amount of reducer to the color; if you have not got any, wetting agent will do.

Always start in the darkest areas first and then work your color gradually toward the lighter tones. Providing that your print is still damp, the gradation from dark to light should be very smooth. As you work toward your lighter tones, keep a careful eye on your lightest highlights, as leaving some small areas completely white will extend the tonal range of your print. While photo dyes dry quite quickly, it is quite easy to smudge your work, so always rest your hand on a clean piece of card.

In order to establish the luminescence that characterizes this technique, it is important that

you build up your colors in layers. It may seem like it takes ages just to work in your first layer, but subsequent applications go on more quickly.

Newcomers to handtinting are often over-concerned with accuracy and, consequently, use brushes that are far too small. You are much less likely to streak your work when using a larger brush, providing you are working with a diluted pigment. If a color bleeds slightly, that is not necessarily a problem, and providing it is not too obvious, it can actually help your image.

One of the main drawbacks of using photo dyes is that it is difficult to eradicate mistakes. If you make one, it is possible to remove it with a solution of water and reducing agent applied with a wad of cotton wool, but that will not remove all the color. If you make a really big mistake, then you will need to wash your entire print in running water, and then start again. But this need not arise, particularly if you get into the habit of working in thin washes.

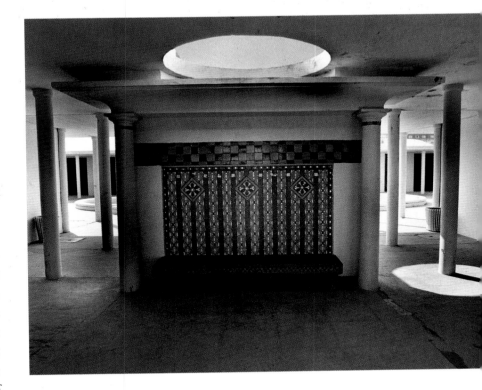

Changing rooms, Deauville, Northern France
While the blue in the skylight could have been created using virtually any medium, the precise mural work can only be done using photo dyes. Try many different handtinting techniques, so you can make an informed choice.

Handcoloring SpotPens

Some photographers who are a little uneasy about their abilities to use a brush have found handcoloring pens a very useful alternative. Kits, such as Tetenal's SpotPens, are an easy way of applying color to photographs, although they do have their limitations. While they are excellent for coloring smaller areas, they are much more difficult to use when undertaking much larger sections. Like photo dyes, these felt-tip pens release a dye that actually penetrates the emulsion of the print.

WHILE IT IS possible to use SpotPens on either FB or RC papers, RC Pearl papers seem to give the best results. Although the pens work reasonably well on FB papers, if you apply the color too vigorously, then it is possible to damage the surface of the emulsion.

In common with most other handtinting techniques, make sure that you have positive highlight detail, as the technique can look over-conspicuous on bald white paper.

Getting started

Before you start handtinting, it is important to dampen the surface of your print. Getting this seemingly simple part of the process right is important. If it is too dry then you may experience streaking, while if your print is too wet, then color is drawn out of the tip of the pen and no color appears to come through. I find the best way to start is to dampen the entire print with a sponge and then mop up any excess with a paper towel.

Before you start using the pens, it is important that you soften them by rubbing all four edges of the tip on a piece of card for at least 20 seconds. Do not worry about causing unnecessary wear—the softer the tip becomes, the less likely you are to scratch your print.

When putting on the color, try to start on a relatively small area, applying it in a soft, circular motion. It is important that you err on the side of caution because if your colors are too intense, they can be difficult to remove. If you see that the color is not going on, check the tip, and if it appears blanched, then your print is still too moist. Similarly if too much color appears to have flooded onto your print, soak it up with a

Rob holding fish

Felt-tips do not work particularly well with large open areas, but they are superb when you wish to add small and intricate detail. In this example I dual toned the print, first in sepia and then in selenium. After slightly dampening the print, I finally added color to the hand, face, and fish.

paper towel. Do not apply too much pressure, again because your colors are likely to become too intense, but also because you could damage the surface of the print.

If you are considering doing larger areas, try wherever possible to break them down into smaller units and complete each in turn. Faultless blue skies are very difficult to achieve using SpotPens, but large textured areas, such as walls and foliage, are quite manageable.

Mixing colors is a little confusing, as you are not dealing with primaries, but it is simply a matter of layering one color over another. You need to remember that you are increasing the intensity of the color with each layer you put on.

Creating highlights
Highlights can be added in one of two ways:
■ First, remove color using the Dye Removing Pen. This should be softened exactly the same as the other pens, and then worked in a circular motion into those areas you wish to lighten. The solution in the pen removes the dye.

■ Alternatively, use a damp sponge or cotton swab to "lift" the dye out of the print. If you choose this method, you need to do it while the surface is still wet.

Possible problems
The main problem is streaking, and this can have a variety of causes:
■ Not blotting up the excess color during application. If your work does get too wet, soak it up with a paper towel.
■ Your pen is not soft enough; to resolve this, rub the tip of your pen on a piece of card.
■ Your print is too dry, so the dye is drying before you have a chance of smoothing it out.

If you wish to remove all the color and start again, the best option is to soak the entire print in a tray of water. Do not expect all the color to disappear as these are permanent markers—the blue and the green are especially stubborn.

Model and graffiti
I was required to use various techniques in order to produce this image. First, I lightly copper toned the entire print; after masking the figure I then toned the background blue, thus creating a dual-tone image. Finally, I used a selection of Tetenal felt-tips to add further color to the figure.

Marshall's photo oils and oil pencils

While you can get very acceptable results from using standard artists' oil paints, Marshall's Oils are designed specifically for use on photographs and, consequently, have certain advantages. First, the pigment is translucent, therefore no fine detail will be masked by this technique. Second, the consistency of the medium is ideal for working on most photographic surfaces. Finally, in order to make them easier for everyone to use, Marshall's Oils come in two forms—in tubes or as pencil crayons.

POINTS TO CONSIDER

■ Only mix up a very small amount of color as Marshall's Oils go a very long way.

■ If you are using glossy RC paper, you will need to pre-treat it with Marshall's Pre-Color Spray.

■ Marshall's Oils provide an easy and direct way to hand-color photographs.

MARSHALL'S OILS ARE a particularly popular method of handtinting photographs because they are easy to apply and the results are permanent.

The oil-color tubes come in a variety of kits ranging from a basic set, which has a limited range of just 9 colors, through to a "Master Oil Set," which offers an enormous variety of color options. It should be noted that if you are a newcomer to handtinting and you are put off by the relatively high cost of this kit, you can mix up virtually any color you require once you have the 3 primaries. All the kits come with tubes of paints that can be applied directly onto the print, or they can be pre-mixed.

All kits come with a bottle of Prepared Medium Solution (otherwise known as PMS), which is the key to using Marshall's Oils successfully, although its main purpose is for cleaning your print prior to tinting. The more advanced kits also come with Extender (which is used to thin and therefore lighten the pigment) and Marlene (which is used to clean up parts of the print after color application). But you will quickly learn that the PMS is capable of doing all three tasks, so you do not have to purchase one of the most expensive kits.

Making a color applicator

1 Smooth flat a section of cotton wool measuring about 2¹/₂ x ³/₄in (60 x 20mm), then wrap it around the moistened tip of a skewer.

2 Fold the cotton wool over the top and roll it around the tip a few times to fully cover the end.

3 Twist the skewer to wrap the wool around the end, while pushing it upward to tighten the wool and create a smooth "bud" or swab.

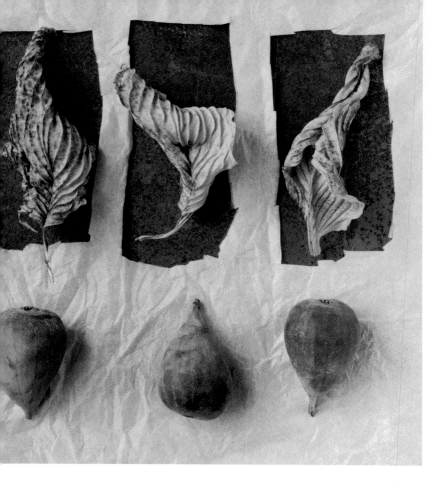

Fresh figs and dried leaves

Small natural forms such as fruits, leaves, flowers, and shells are ideal for developing your skills with Marshall's Oils. They are particularly effective when you wish to gradate your colors within a relatively small area, as with the figs in this photograph. Prior to tinting, the image was dual toned with sepia and then copper.

Kate with patterned blouse

Portraits are very easy to do with Marshall's Oils, as flesh colors are already pre-mixed. It is important that you use either red or brown to darken the tones; this technique can look overconspicuous on bald white paper.

Suitable papers for Marshall's Oils

Marshall's Oils work well on either RC or FB papers. However, they do seem to resist glossy RC papers, unless they have been pre-treated with Marshall's Pre-Color Spray. They work well on FB glossy papers, but are particularly well suited to pearl and matte surfaces, as the paper appears to grip the pigment. In my opinion, textured art papers such as Kentmere Art Classic and Fotospeed Tapestry can overexaggerate the effect—however, handtinting is a personal thing, and it is important to experiment with a range of paper types to see what works best for your particular requirements.

The process

The oils are applied using wads of cotton wool for the larger areas, or by using color applicators. All kits come with small wooden skewers, which are designed to be made into applicators (as shown opposite).

It is also possible to use cotton swabs, except that they are small, are not very absorbent, and can only be used for very small detail.

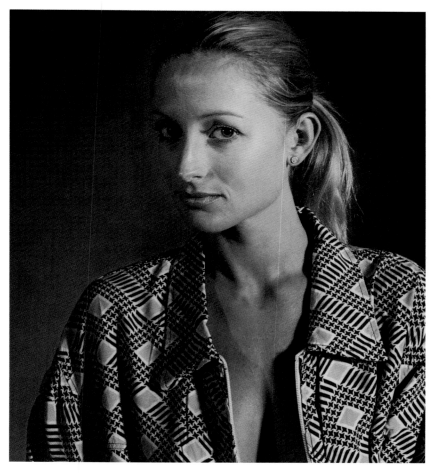

Reflection

The real joy of working with Marshall's Oils is that you can use them in conjunction with oil pencils. Most of the color has been applied using Marshall's Oils, although the eyes and mouth have been done using pencils.

Apply the larger areas of color with wads of cotton wool, while using self-made applicators or cotton swabs for smaller areas of detail.

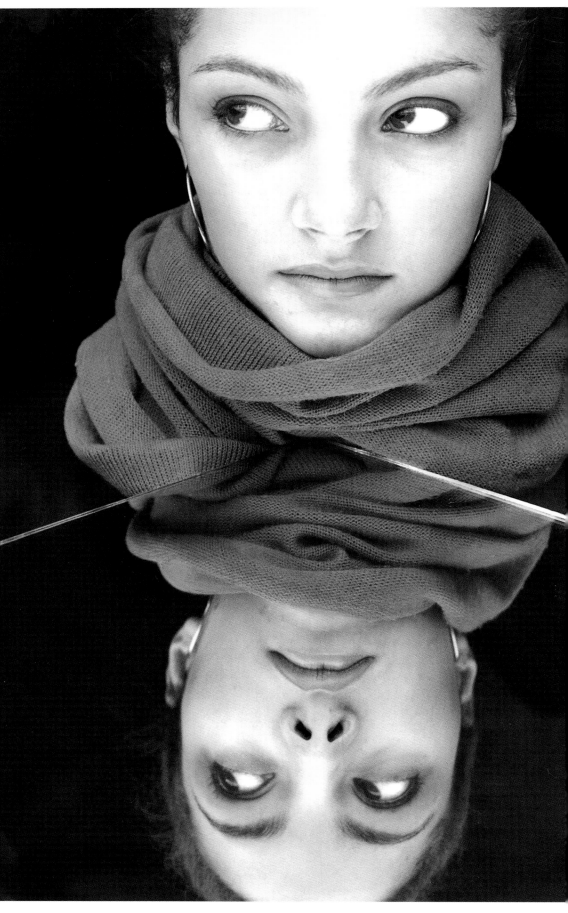

Applying the basic color

Each handtinting medium has its own unique characteristics, and Marshall's Oils work far more effectively if you are prepared to build up your colors in layers.

Newcomers to this technique are often seduced by the strength of the colors and try to achieve a maximum saturation of color in just one application; if you try this, you risk obliterating subtle tonal detail, and your picture will look both gaudy and flat.

Learn to exercise restraint; aim to block in the largest areas first, applying the color in a circular motion and keeping the layers thin. I find that preparing your print with a very thin coat of PMS solution prior to applying the color helps to get the correct consistency and density.

Do not be overconcerned about "going over the line." In order to build up large smooth areas, it is important that you work quickly, which does mean that initially you need to disregard boundaries. Note that a key feature of Marshall's Oils is that when you apply a second color, it completely neutralizes the first, so correcting mistakes is easy. What you must avoid is a build-up of colors at the edges. Once you have blocked in all the main areas, begin to work in the detail.

Marshall's oil pencils look identical to normal coloring pencils and are just as easy to use.

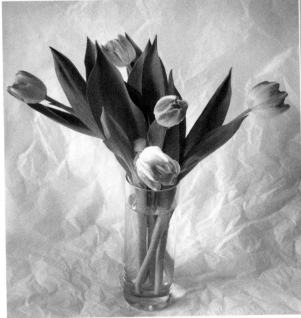

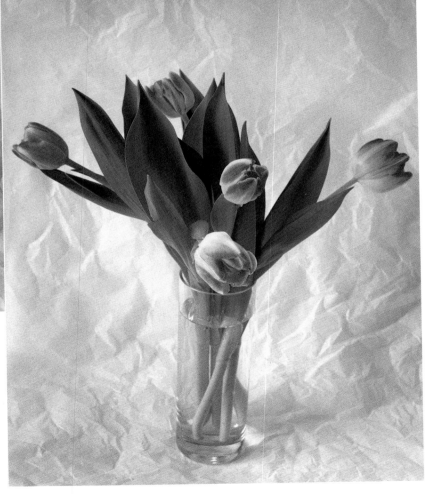

Tulips

While I did not want to start from a pure black-and-white base, I nevertheless required a very quiet background from which to work. I therefore opted to gold tone this print, just to give a very slight suggestion of blue. The color in the tulips has been added using oil pencils. Providing you are prepared to build up your colors in layers, you can achieve quite strong and luminous hues.

Creating highlights

Highlights play a crucial part in any handtinting process if you want the elements to appear three-dimensional. These can be created in a variety of different ways:

1 Work your oils from dark to light, thereby creating your highlights as you apply your color.
2 Wipe out the color with a small piece of cotton wool, making sure you blur the edges.
3 Try using a very small amount of PMS or Marlene on a cotton swab, and then work it into your highlight. This method works particularly well after trying the second method, just for cleaning up the highlights a little.

4 Try using a Faber Castell Peel-Off Magic Rub vinyl eraser. If you are unable to get one, try using an old-fashioned typist's eraser. If you get any debris as a result of this, resist the temptation to brush it away with your hand; use a blower brush instead.
5 Finally, if you find that you really do not like what you have achieved, you can remove all the color using Marlene. Providing you work with care, it should never come to this.

It is important that you give your finished work plenty of time to dry. Obviously the drying time depends on the amount of pigment you have used, the ambient temperature of the

Fruit and vegetables
Prior to handtinting, all 9 images were sepia toned in order to create a consistent base for the Marshall's photo oils. I worked directly from life in order to retain the authenticity of the colors. The very fine detail can be added later using oil pencils, but only after the oils have had an opportunity to dry. While as individual images these can look rather unexciting, they do greatly improve when grouped together.

room and the humidity—but allow at least 4 days. Once the print is dry, you may then wish to add further detail using Marshall's oil pencils.

One final point you may wish to consider is that a much richer intensity of color can be achieved if you use photo dyes prior to using oils. Photo dyes are capable of soaking into the emulsion of the paper, thus creating a very stable base; by working your Marshall's Oils over this, you can achieve a depth and luminosity, that cannot be achieved in any other way.

Oil pencils

When using oil pencils your approach will be quite different than when using the tubes of oil, as you are able to work far more precisely—you should be able to achieve the same richness of color, as they are made from the same compound. They look just like ordinary pencil crayons and can be sharpened to give you a very fine point.

Whether you opt to use Marshall's Oils or oil pencils is a matter of choice. Printers who are inexperienced at using artists' materials generally opt for oil pencils in the mistaken belief that they are easier to use; this is not necessarily true.

In common with the oils, it is important that you pre-treat the surface of your print with PMS; and it is equally important that you soak up any excess.

Again, it is useful to work in your larger areas first, and this is where some novices to this technique begin to experience difficulties. Try to

Artichokes

It is important that you are patient when using oil pencils. Initially, the larger areas were laid in, but were then allowed to dry before some of the more detailed colors were added. Try to restrict yourself to just a few colors; in this example, I used green, yellow, blue, and flesh brown.

build up a quick and even shading style using the pencil edge and not the point.

I generally think it is best to work lightly, so as to build up various layers. Once you have achieved the density of color you are after, gently buff the surface with a clean wad of cotton wool, and any irritating pencil lines should fuse into the color.

If you wish to create a sharply defined edge, butt a piece of paper up to it, to protect the area from being shaded, which will allow you to work far more fluidly.

Mixing colors

Don't be fooled into buying the biggest box of pencils you can afford because, irrespective of how many you have, you will still need to mix. I have a set with just 9 colors, plus white, and I find that I am able to mix virtually any other color from them. For example, if you have a red

"M"

It is not easy to color large open areas without leaving blemishes. The crucial thing is to work in your largest areas first, regardless of the smaller detail. With Marshall's Oils, when you lay one color over another, the second color neutralizes the first; they don't mix. Corrections are therefore easy to do.

Mulkey

While this might look like a very difficult subject for oil pencils, it is perfectly possible to shade in large open areas. I smeared a very thin layer of PMS over the surface of the print and then applied the color with the edge of the oil pencil. Using wads of cotton wool, I carefully worked it in, butting the straight edge of a piece of paper over areas I did not want to be colored. I have tried to make good use of two complementary colors, blue and orange, to introduce a little more punch into this image.

and a yellow, you can mix orange. The critical thing is to lay down your first color as evenly as possible, and then to work your second color over it. If you want to gradate your color, that is just as easy to do.

Suitable papers

The best surfaces for handtinting with oil pencils are matte FB papers such as Ilford MG FB matte and Forte Polygrade FB V semi-matte.

Oil pencils do not work well on RC papers, or on highly textured papers, as the shading becomes just a bit too obvious.

Finally, Marshall's Oils and oil pencils are complementary and work exceptionally well together. My own preferred way of working is to block in the main areas you want colored with oils, then leave the print to dry for a couple of days. I then work in the smaller, more detailed areas with oil pencils.

Gouache and watercolor

Watercolor is possibly the best-known of all artists' pigments, and it is often assumed that it is easy to use. It is undoubtedly easy to carry around, which is why it has gained such popularity with those wishing to work on location; however, it is a technique that demands considerable skill. The prime artistic quality of watercolor is its transparency, which makes it an ideal medium for handtinting. Gouache, like watercolor, is a water-based medium. However, the pigment is more coarsely ground, and therefore can be used either translucently or opaquely.

Biker in the Badlands
Watercolor and gouache are not specifically made for handtinting photographs, so you need to give serious consideration to the paper you use. Use an FB matte surface, or a photo art paper.

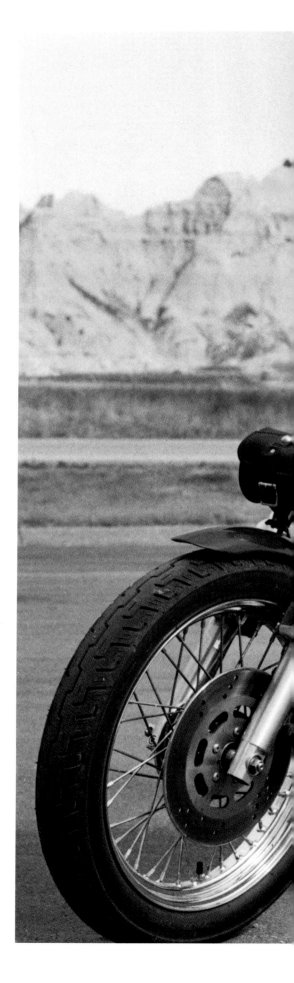

UNLIKE OILS OR acrylics, watercolor and gouache need to be soaked up by the brush, so it is important to buy a good range of soft, specially made brushes.

The brush size depends on the style of handtinting you wish to adopt, but generally speaking, most inexperienced workers opt for a smaller-sized brush when really a larger one is required. If your brush is too small, your painting style can appear patchy and rather labored. As you will be required to apply your colors rather thinly, you can afford to be a little bolder when layering on the paint. If you think you are likely to do a lot of handtinting using gouache or watercolor, I would strongly advise you to buy the best brushes possible, ideally Kolinsky sable.

Paint consistency

Unlike photo dyes, gouache and watercolor are not specifically made for handtinting photographs, and some consideration should be given to their consistency. Before applying the color, try testing it on the back of your hand. If you need to press the brush in order to paint a straight line, your paint is too thick; if when you paint in your line, paint beads appear on the back of your hand, the paint is too watery.

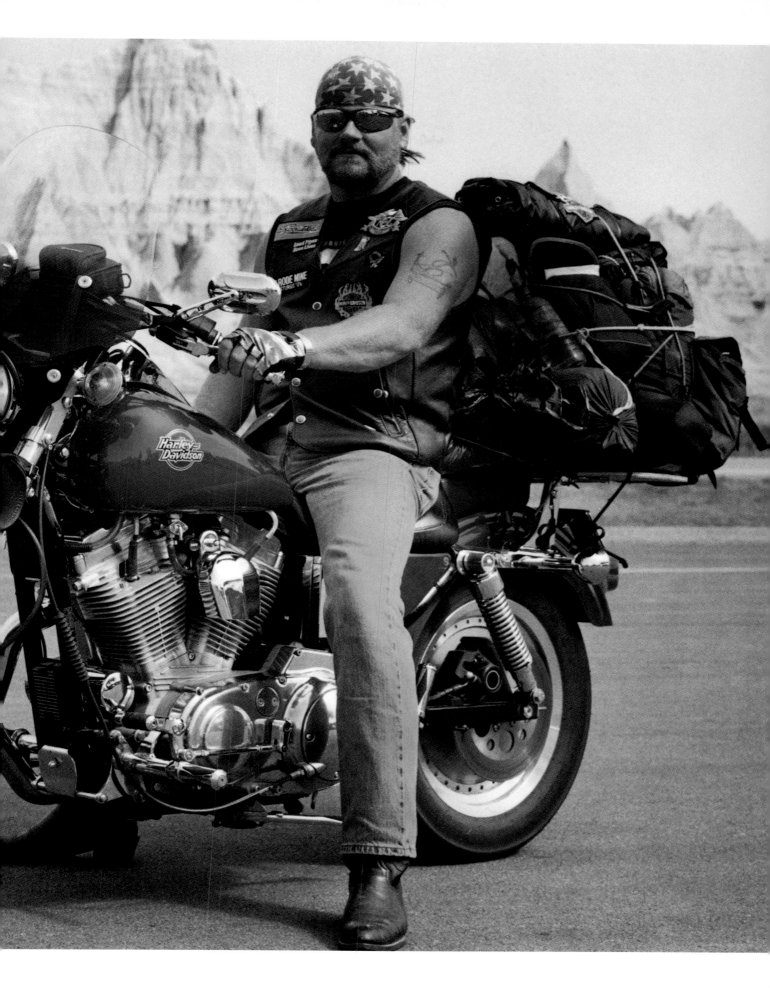

The perfect consistency should allow you to paint a smooth, uninterrupted line.

Suitable papers

Some photographic papers are more suited to this technique than others. Art-based photographic papers such as Kentmere Art Classic and Document Art seem to produce the best results. You could also try coating liquid photographic emulsions onto heavy-duty watercolor paper as this approach seems to work particularly well too.

If you decide to use more conventional photographic papers, steer away from those with a gloss surface, because you will have more success trying to nail yogurt to the ceiling! Masking should not be a major consideration, although if you do want to achieve a "hard-edged" effect, then try using masking tape.

To help get an even application of color, soak your print in lukewarm water for 15 minutes. If you are using an art-based photographic paper, tape your print onto a clean drawing board after soaking, using fairly broad strips of gummed

tape. This not only attaches the print onto the board, but also helps to stretch the paper. When fully soaked, it will naturally start to pucker, but this is reduced once it is taped down. As your print dries, the tape prevents it from contracting, and the paper is stretched. This prevents puckering when further applications of water are made. At this stage, it helps to incline your board at about 30°, which then encourages the water to seep down the print.

If the surface is too damp, try mopping it with a paper towel. Work your largest areas first, using a very diluted pigment. If you are doing a sky, apply the paint in broad, uninterrupted strokes, working from the top downward. Use a large brush and do not be put off by the apparent streakiness; if your paper is damp enough, the paint seeps evenly downward. As you work in the more detailed areas, you can afford to use your paint more thickly.

Smudging your work is a constant worry, as watercolor paints and gouache dry much more slowly than photo dyes. Try resting your hand on a small piece of paper or light card.

Finally do not be too concerned if one color slightly bleeds into another, as this is one of the unique characteristics of watercolor that can lend a certain charm to your work.

Creating highlights

There are three ways of establishing highlights when using gouache or watercolor paints:

1 Paint carefully up to your highlight, thinning the paint as you do so. One way of creating a smooth gradation is to place a small drop of water directly over the highlight.

2 Ignore the highlights completely to begin with. Then "lift" the color out later once it has dried. This can be done by working the required highlight with water, then soaking it up with a clean paper towel. You will create a highlight with just a trace of the previous color, which can look extremely plausible.

3 My least favorite method is to paint the highlights back with white paint. While this can work reasonably well on a matte paper, it looks very obvious on pearl or glossy paper.

There are many advantages to using watercolor or gouache; these media can be applied directly, they are cheap and convenient to buy, and if you have never tried handtinting before, then this might well prove to be the most appropriate start. But as they are not specifically made for photographs, they have limitations. Moreover, many watercolor or gouache images are likely to fade in strong sunlight.

Gold Crown

While it is possible to color large open areas using gouache, best results are achieved when working-in small and intricate detail.

Airbrushing

Unlike many other techniques, airbrushing is dependent on you developing quite specific skills and possibly acquiring expensive specialist equipment. But if you do decide to go down this path and spend time developing key airbrushing skills, you will discover an unparalleled handtinting technique that allows you to produce spectacularly beautiful images. Airbrushing is possibly the best way of handtinting a photograph, because once you have gone to the trouble of cutting out your masks, it is quick and highly effective. It also has the added advantage that the process closely parallels the natural grain of the print.

For those who have never seen an airbrush, it is about the same size and shape as a fountain pen, except that it is attached to an air hose. It works by sending a highly pressurized jet of air over the liquid, which is then vaporized and forced through an air jet.

Types of airbrush

There are principally two types of airbrush—single-action and double-action:

The single-action is the simplest of airbrushes. You pre-set the air flow before you start airbrushing. These airbrushes vary in design, and some are very cheap indeed, but if you are going to use one, make sure that it operates with a central needle, and that your minimum air-flow is at least $^{1}/_{8}$in (3mm).

The reservoir (the vessel that holds the paint) is usually a glass jar that screws into the bottom of the airbrush. The big advantage is that it will hold a lot more fluid than a double-action airbrush, but the glass bottle can make handling a bit difficult, especially if you wish to do very fine airbrush work.

Double-action airbrushes

The double-action airbrush is more sophisticated and more expensive, and is generally the type of airbrush used by professional illustrators and advertising retouchers. You are able to control the flow of air and the paint supply simultaneously, by pressing down to increase the air flow and then pulling back on the trigger to increase the paint flow. While this is a skill that needs to be mastered, it means you are able to make subtle adjustments as you work.

Most double-action airbrushes are gravity-feed, which means that they have a small, hollow bulbous extension on the top of the airbrush that serves as the reservoir. The big advantage of this is that it is much easier to handle, even when doing very fine detail.

Either type of airbrush can be used extremely effectivity when handtinting photographs, except that you are able to exercise a little more control with a double-action airbrush.

Air supply

This can be achieved in one of three ways:

■ An air can—this is virtually identical to an aerosol, except that it does not have a spray-head. While in the short-term it may appear to be your cheapest option, you will quickly appreciate that it is not, when you find you are constantly having to buy replacements. It does have other, more serious drawbacks. First, it does not give you a constant pressure, and therefore is very likely to splatter as the pressure decreases. Second, it does tend to freeze up even after only a relatively moderate period of time, so you are not able to plan any extended airbrushing sessions.

■ A car tire—while this may not prove to be

This is a cross section of a single-action Daler Rowney Aztec 1000S airbrush; suitable for all aspects of handtinting photographs. It is quite different from the model featured on page 116, which is also a single-action brush. An airbrush is a complex mechanism and it is important to rinse it thoroughly—with turpentine (if you have been using oil-based paint) or water (for water-based paint)—immediately after use.

a very pretty way of working, it is both cheap and reasonably effective. All you need is an old tire still on the rim, and a specially made adapter. You then need to ensure that you keep the pressure at no more than 40psi, but no less than 30psi; if the pressure exceeds either of these figures, then your airbrush will start to splatter.

■ AIR COMPRESSOR—if you wish to take up airbrushing seriously, then you ought to consider getting an air compressor. It may appear to be quite expensive, but when you set this against the cost of most other photographic equipment, it does not seem so daunting. There are quite a number of different compressors you can buy, varying greatly in cost and quality.

Masking your work

When you are airbrushing, you are inevitably going to experience color straying, therefore masking is a fundamental part of the process. The ways of doing this are comprehensively covered in the section on selective toning on pages 76 to 79. Use masking film for larger and regular areas, but masking fluid for smaller and irregular areas. When cutting straight lines, a steel ruler works wonderfully; cutting circles can be rather more difficult.

Cutting circles

One tip you may care to try is to use a compass that has an inking attachment. Remove the nut and washer, and then place a scalpel blade carefully between the two prongs so that the hole in the blade is in line with where the nut and washer should go. Put the nut and washer back in place, tighten it up, and you then have an ideal instrument for cutting circles. If you are concerned that the point of the compass is going

Mazda in the Badlands
This was taken on my first trip to America. Having taken various location shots within the area, I returned to our rental car and was struck by how impressive it looked set against the beautiful Badlands National Park. First the entire image was blue toned, and then I cut two masks, one for the sky and a second for the car. Orange was chosen because it is opposite blue on the color wheel.

Old letters (OPPOSITE)
The print was sepia toned, then the orange detail in the wallpaper pattern was painted in by hand, using photo dyes. The entire image was then covered in masking film, and masks were cut out to expose the table and wallpaper. I airbrushed the table blue and the wallpaper purple. Most pigments are translucent, so you can airbrush over previously painted detail.

Using an airbrush
An airbrush is about the same size as a fountain pen that is attached to a compressor.

This is a single-action airbrush; the width of the spray can be controlled by adjusting the screw at the back.

It is far easier airbrushing your work when it has been attached to a vertical surface.

to damage your print, put a small sticky cardboard pad where the point should go, this adheres to the masking film, but not the print.

What medium should I use?

Before making a decision, you have to consider two issues—first, which dyes, inks, or paints can be safely put through the airbrush without clogging up the very fine jet; and second, which of these media is the most suitable for handtinting photographs?

Theoretically, you should be able to put through virtually any pigment, providing that it can be reduced down to a liquid form that has a consistency no thicker than milk. It is also important that whichever medium you are using, you are able to use an appropriate cleaner or solvent afterward.

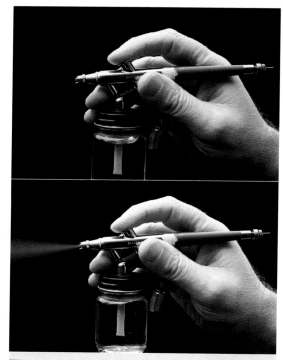

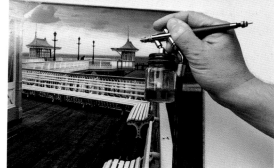

You will also need to consider the opacity of the medium; while there may be occasions when you wish to obliterate parts of your print, generally the idea is that you want the photographic detail to show through, so translucent pigments should always be used.

These are some of the different media that you can try with your airbrush:

■ FOOD DYES—these are very cheap and can easily be bought from most supermarkets. They come in a sufficient range of colors, they flow through any airbrush very easily, and if you are doubtful about airbrushing your work, then these are a useful first option. The main drawback is that these colors are not lightfast and are likely to fade quite quickly.

■ PHOTOGRAPHIC DYES—in many people's eyes, these are the perfect medium for airbrushing photographs, largely because they are the ideal consistency, and also because they are water-based, therefore they are easy to clean afterward. They generally come in kit form, comprising 12 or 13 small jars. Unfortunately this can prove rather wasteful, as certain key colors tend to run out faster than others, which then often necessitates buying a whole new set. If you are concerned about permanence, and if you are thinking of selling your work, then they are a much better option than food dyes.

■ KODAK E6 TRANSPARENCY RETOUCHING DYES—if permanence is the main issue, then these dyes are probably your best option. They have been designed principally for retouching transparencies but are not cheap; moreover, they only come in three colors, magenta, cyan, and yellow. However, photographically speaking these are the three primary colors, and you should be able to recreate virtually any other color by overlaying one over another, especially with an airbrush. One of the other major advantages is that you can buy these colors separately, and they can be used together with photographic dyes.

■ DALER ROWNEY FW INK—this is an acrylic-based, pigmented, water-resistant ink, which can, nevertheless, be diluted with water. It comes in a wide range of colors, most of

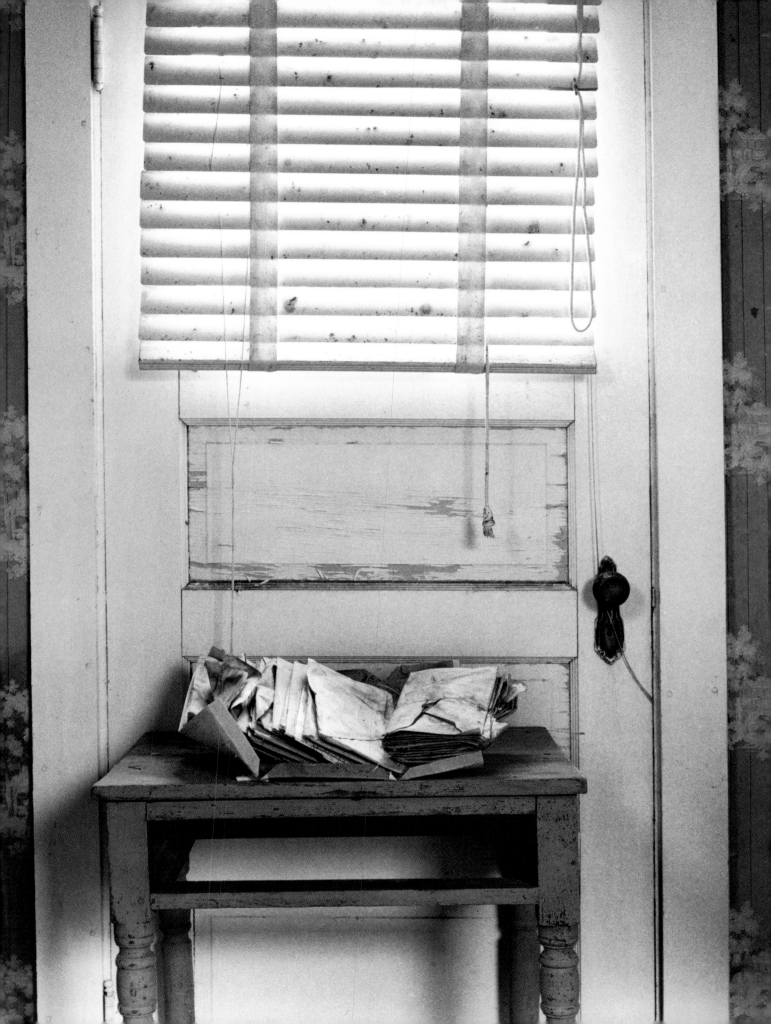

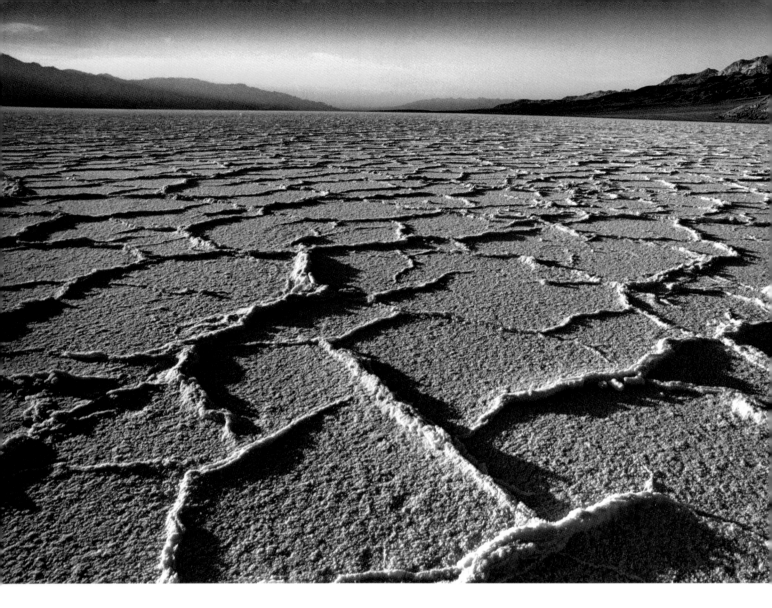

Salt plains, Death Valley

Sometimes handtinting can prove to be ridiculously easy, yet quite effective. In this example, I toned the entire print blue, and then added a small amount of color just above the horizon in order to increase the feeling of dusk.

which are permanent. There are two types of FW inks: translucent inks, which show photographic detail, and opaque inks. While common sense suggests that you use the former, there may be some limited use for the latter.

■ WATERCOLOR PAINTS—if you are going to use these, then I would recommend that you opt for artists'-quality watercolors. The colors are translucent, which again makes them ideal for handtinting photographs, except that it is important that you dilute the pigment with water so that it can easily pass through the airbrush. Airbrushing watercolor onto a photograph is easier than applying it by hand, although you will experience enormous difficulties applying it to RC papers.

■ GOUACHE—this is also a water-based pigment that superficially is very similar to

watercolor, except that it it is opaque, therefore the more layers of color you spray on, the less photographic detail will be visible.

■ ACRYLICS—while you are able to get very rich and permanent colors with acrylics, they are opaque. They can also clog up your airbrush unless you are particularly punctilious about cleaning. I would not recommend using them.

How to apply the color

There is a mistaken belief in some people's minds that you need to accurately mix up your colors before you start airbrushing, but this could prove wasteful, both in terms of paint and time. For example, if you wish to achieve a green and do not have one, all you need to do is to spray in a layer of yellow and then follow that with a layer of blue. As the color is very finely

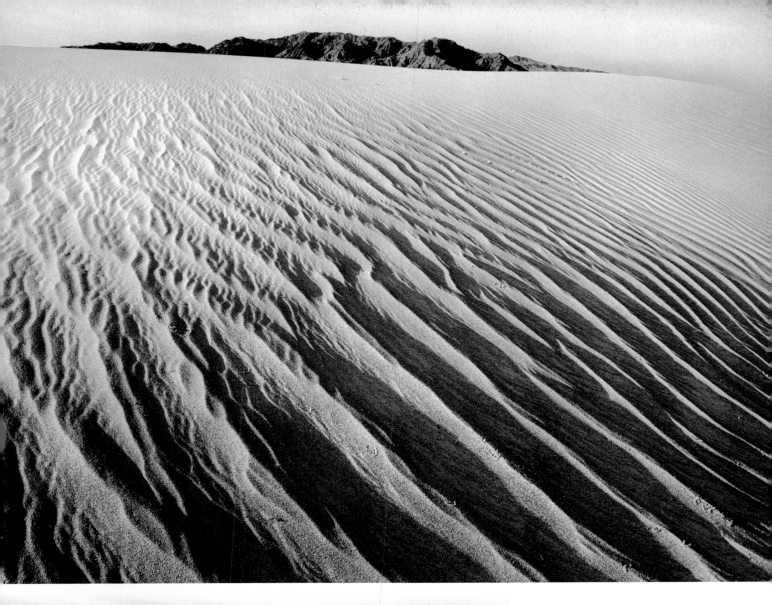

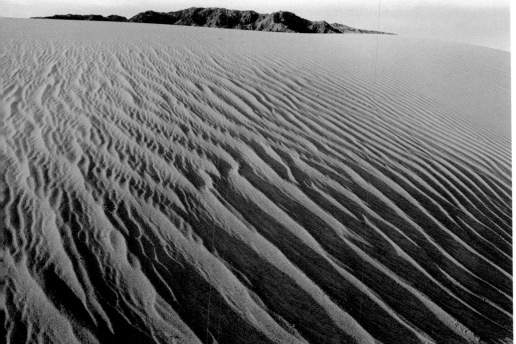

Death Valley

VERSION 1 (LEFT): I always felt that this was a good negative, but perhaps because there was very little in the sky, it did not work particularly well as a straight black-and-white print. Even when toned, it did not quite make it.

VERSION 2 (ABOVE): In this print, I bleached out some of the lighter parts of the sand dune with "ferri" prior to sepia toning. I then had the relatively simple task of masking the sand dune and airbrushing in the sky. Once you have elements of the three primary colors (yellow, red, and blue) in your print, the balance seems to work.

Yellow stripes

VERSION 1 (BELOW LEFT):
A straight print showing
the colors that actually
existed.

VERSION 2 (BELOW RIGHT):
What really caught my
attention when taking
this photograph was the
large yellow stripe in
the background, which
appears to echo those
across the model's chest.
In order to introduce
some measure of visual
unity, I tinted the stripes
on her pullover the same
color as the one in the
background. The joy of
handtinting is that you
are able to precisely
determine the final
outcome.

Matthew's blue pullover
Airbrushing in color is undoubtedly the easiest way of
handling large areas such as the backgrounds. To achieve
this, I lightly sepia toned the entire image. I cut a mask for
the figure and then airbrushed the background using cyan
and brown dyes. Another mask was cut, this time just
revealing just the pullover, which again was carefully
airbrushed. Finally, the head was tinted using a
conventional art brush and photo dyes.

Taking care of your airbrush

It really is essential that you clean your airbrush
thoroughly after use. As a rule of thumb, never
allow a period longer than 3 minutes without
passing a solvent (usually water) through your
airbrush. Remember that the jet in your
airbrush is exceptionally fine, and it is very easy
to block it up. I generally try to get 2 or 3 jars of
clean water through, with the jet wide open,
before I consider that my airbrush is clean
enough to put away.

If you do experience a blockage, don't panic
as they are easily dismantled and cleaned, but
you must take great care not to damage the tip
of the needle. At the start of any airbrushing
session, check the needle, and if it does look
damaged, replace it. Finally, when not in use,
always remember to replace the metal cap over
the spray head, as the needle is by far the most
vulnerable part of the tool.

atomized, optically, the tiny dots of yellow will
mix with the tiny dots of blue, and what you
will see is green. Remember that most paints or
dyes dry on contact, so it is very easy to build up
layers of color. The big advantage of working in
this way is that you can determine the precise
hue far more accurately. The other advantage is
that you are much more likely to gradate
your color, which closely resembles what
happens in nature.

From an economic standpoint, if you do mix
up your colors and then discover you have too
much, you generally have little option but to
pour it away, while unmixed solutions of colors
can always be poured back into their jars.

Things that can go wrong

■ If your airbrush is splattering, it could be either that your pigment is too thick, or the air pressure is too low. If you notice that it is splattering in one direction, then check your needle, as it is likely to be damaged.

■ Always start and finish your airbrushing off-work, otherwise you will see unwelcome blobs.

■ Build up your color gradually; it may take several applications before you achieve the desired density of color, but most pigments dry on contact, which cuts waiting time.

■ Try to avoid "arcing." The natural tendency of the arm is to move in an arc, so it moves close to, and then away from, the surface of the work. Try to ensure that the airbrush remains parallel to the work surface.

■ If your work is getting too wet and there is an appearance of "spiders" on the surface of your work, you are either too close or too much paint is coming through the airbrush.

■ If you see an imperfection, don't try to immediately solve it by localizing the airbrush. If you carefully build up your colors in layers, most problems will disappear.

■ Wash your brush thoroughly. Most pigments are water-based, but if you are using a non-water-based paint, it is important that you check to see that the thinner does not harm the delicate mechanism in the airbrush.

■ If you are using masks, remove them with care; you could quite easily ruin a piece of work in which you have invested many hours of work.

Car show

While this may look fairly complex, again it proved to be very easy to do. The entire image was toned blue, and I then cut a mask to reveal the sky, adding just a very small amount of color to draw attention to the hat. I then cut another mask, this time exposing just the windows, but then gradated the cyan into the magenta to give the image more depth.

Handtinting color prints

Color printing can be a frustrating process. While it is easy to burn-in when printing in black and white, it is not so easy when using color. Another problem is that not only do you need to retain the correct tones, but you also need to ensure that your color balance is right. There is less help available, too: no multi-contrast papers, and no bleaches and toners to increase and decrease contrast. It is a small wonder that even more color prints are not thrown in the trash can. But if you have acquired confidence with handtinting techniques, help is now at hand.

Abandoned farm and Chevrolet

(*photograph taken by Eva Worobiec*)

VERSION 1 (ABOVE): While potentially interesting, this image was taken on a particularly dull day, resulting in this bald white sky.

VERSION 2 (BELOW): When handtinting color photographs, it is important that you are guided by the colors that already exist in the picture. In order to suggest dusk, this was printed slightly warmer and darker than in the earlier version, thus establishing the correct visual scenario.

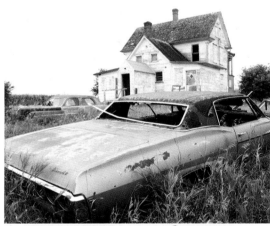

HANDTINTING WILL WORK on either color negative or Cibachrome prints, although the results may well work better on a non-glossy paper. Not all handtinting techniques will work, as the range of printing papers available is not as extensive as with black and white. It is also important that you appreciate that the tenor of the picture is already established, therefore a more creative use of color will be greatly restricted. If you are working on a "warm" landscape, for example, creating a cold blue sky might not prove to be the best solution. The color of the sky determines the color of the landscape, as it is the major source of light, so land and sky should appear in harmony.

Airbrushing

Airbrushing is unquestionably the best method for tinting color prints—largely because the mechanistic nature of airbrushing means that you can apply the color without it being detected. It is particularly useful for adding color to bland skies on those occasion when the negative is so dense that very little detail can be printed. Because Kodak E6 dyes have been specifically designed for retouching color prints, they are the perfect medium to use.

Photo dyes

Photo dyes are another worthwhile option, although you should try to restrict their use to very small areas. Unlike tinting black-and-white photos, you already have an established color base from which to work; so it is essential that you mix your color with care and ensure that it matches. It is also very important that you build up your colors in thin washes.

Marshall's Oils and oil pencils

Marshall's Oils work far better on FB papers, but such surfaces do not exist in color. They do work on satin papers, but it is difficult to achieve deep and luminous colors without the technique showing. They seem to work best when used to darken detail already in the print.

If you wish to use Marshall's oil pencils, do not use them directly, otherwise you could indent the surface of the paper. Instead, smear the surface with PMS solution and apply the color with the side of the pencil, smoothing in the color with a wad of cotton wool.

Bryce Canyon
VERSION 1 (ABOVE): When I took this color photograph, I failed to use a graduated filter, resulting in a sky that is hopelessly overexposed. When I tried burning-in, the results were muddy and rather obvious. VERSION 2 (BELOW): By handtinting in the sky, I was able to rectify the mistakes I made at the shooting stage.

Mixed media

If you do intend to take up handcoloring seriously, you will solve a number of problems if you are prepared to use not just one, but a variety of techniques on the same print. Each process has its own strengths and its own limitations, but in order to be successful at handtinting, you should assess your print and then establish the best way to proceed. Just remember that although any print can be handtinted, not all prints can be convincingly tinted using just a single method.

Sportsman
In the original print the sky was very dull, doing little for the shot. However, by air-brushing it using FW acrylic inks, it becomes a more significant part of the picture. The remaining colors were added using Marshall Oils and oil pencils, and photo dyes.

WHEN HANDTINTING WITH a variety of different media, it is important that you observe certain key rules, otherwise the different processes are liable to conflict. It is therefore important that you think through your approach, ensuring that you utilize all the media to its best advantage. Here are some commonly encountered examples:

■ While you can achieve some beautifully luminous colors when working Marshall's Oils on top of photo dyes, you cannot apply water dyes over the top of oils.

■ If you airbrush with acrylics, you should be capable of achieving fabulously deep colors. However, the medium will tend to block the surface, so do not expect to be able to work any other medium over it.

■ When intend working with a water-based medium next to an oil-based medium, you should again make sure that you apply the water-based medium first. If you start with the oil-based pigments, the oils can easily seep into adjacent areas, causing problems if you then wish to use a water-based medium.

The Driftwood Cafe

This was a complex image to handtint, and could only be tackled using a variety of techniques. The image was first lightly sepia toned, then the sky, the car in the foreground, the green awning, and the distant wall to the extreme right were all airbrushed using E6 dyes. The remainder of the picture was tinted using a variety of methods including oil pencils, photo dyes, and even a small amount of oil paint. There is no need to undertake something quite as difficult as this, but once you have experienced various tinting techniques, you can discover the fun of experimenting with several in one print.

Zoe wearing a tie-dye shirt

When I initially saw this as a straight black-and-white photograph, I was tempted to believe that it could not be handtinted. But when I considered the many options available, I gradually began to realize that it could be done. To solve the problem, I first masked the figure and airbrushed in the background, adding the marks and stains with oil pencils. The arms, head, and midriff were tinted using Marshall's Oils, while the very fine patterns on the T-shirt were emphasized using photo dyes. More detail could still be added, but in my opinion it is important to retain a balance.

Index

Acknowledgments

Inevitably with a book of this nature, help is sought from a variety of sources and I am especially grateful to the following people: To Sarah Hoggett of Collins and Brown for commissioning this book and to Roger Bristow and Emma Baxter who quietly guided me in the right direction. I am particularly grateful to John Herlinger of Fotospeed for spending countless hours showing me how to use chromogenic toners tastefully, and to Michael Maunder of Speedibrew, for his learned expertise and for what seemed to be a constant supply of chemicals and toners. I am deeply grateful for the assistance I got from Daler Rowney, Tetenal and Calumet KJP, and also to MPA of Bournemouth whose good-natured professionalism was second to none.

But I must reserve particular thanks to my very good friend, Jeremy Guy, and to my wife Eva who literally did make this publication possible. Mid-way through I sustained a serious injury which made any further work appear impossible. Without their assistance, their constant encouragement, forbearance and good humor over the last three months, their willingness to ferry me around, and their capacity to endure my tantrums, born out of sheer frustration, I would undoubtedly have given up. Believe me when I say that I am truly grateful.

Tony Worobiec

Suppliers

USA

B & H Photo
420 9th Avenue,
New York, NY 10011
Tel: +1 (212) 444-6600
Toll free: +1 (800) 947-9970
www.bhphotovideo.com
*Film, photographic paper, darkroom
supplies, Marshall's Photo Oils. Also
mail order—call for catalog.*

Badger Air Brush Co.
9128 W Belmont Ave.,
Franklin Park, IL 60131
Tel: +1 (800) AIR-BRUSH
Fax: +1 (847) 671-4352
www.badger-airbrush.com
*Manufacturers and suppliers of
airbrushes and compressors.*

Calumet Photographic, Inc.
16 West 19th Street,
New York, NY 10011
Tel: +1 (212) 989-8500
Mail order: +1 (800) CALUMET
www.calumetphoto.com
*Photographic supplies, Marshall's
Photo Oils. Mail order and retail
outlets in New York, California,
Illinois, London, Belfast, Edinburgh,
and other locations—call or see
website for complete listing.*

Dick Blick Art Materials
P.O. Box 1267,
Galesburg, IL 61402-1267
Tel: +1 (800) 828-4548
www.dickblick.com
*Marshall's Oils, artist's watercolors,
paintbrushes, and much more; 35
retail stores nationwide and mail
order—call or see website for catalog
and list of stores.*

Ilford Imaging USA
West 70 Century Road,
Paramus, NJ 07653
Tel: +1 (201) 265-6000
www.ilford.com

Kodak Ltd USA
Tel: +1 (800) 242–2424
(information center)
Fax: +1 (800) 755-6993
www.kodak.com

Luminos Photo Corp.
P.O. Box 158,
Yonkers, NY 10705
*Suppliers of Fotospeed toners,
developers, and photographic papers.*
Tel: +1 (800) LUMINOS
www.luminos.com

Marshall's
www.marshallcolors.com

Pearl Paint
308 Canal Street,
New York, NY 10013
Tel: +1 (212) 431-7932
Toll free: +1 (800) 221-6845
International mail order:
+1 (212) 431-7932
www.pearlpaint.com
*Marshall's Photo Oils, artist's
watercolors, paintbrushes, matting
and framing materials, and much
more; 19 outlets nationwide and mail
order—call for catalog and list of stores.*

UK

Calumet UK
Promandis House,
Bradbourne Drive, Tilbrook,
Milton Keynes MK7 8AJ
Tel: +44 (08706) 030 303 (sales)
www.calumetphoto.com

C. M. Direct
Creative Monochrome Ltd,
Courtney House, 62 Jarvis Road,
South Croydon, Surrey CR2 6HU
Tel: +44 (020) 8686 3282
Fax: +44 (020) 8681 0662
www.cremono.com
*Mail order suppliers for most papers,
toners, and chemicals.*

Daler Rowney Ltd
P.O. Box 10, Bracknellp RG12 8ST
Tel: +44 (01344) 424 621
Fax: +44 (01344) 486 511
www.daler-rowney.com
*Suppliers of art materials and
airbrushes.*

Fotospeed
Fiveways House, Westwells Road,
Rudloe, Corsham,
Wiltshire SN13 9RG
Tel: +44 (01225) 810 596
Fax: +44 (01225) 811 801
www.fotospeed.com
*Makers of Fotospeed toners, Fotodyes,
lith papers, and developers.*

Ilford Imaging UK
Town Lane, Mobberley,
Knutsford, Cheshire WA16 7JL
Tel: +44 (01565) 684 000
www.ilford.com
*Manufacturers of an extensive range
of printing papers.*

Kentmere Ltd
Staveley, Kendal, Cumbria LA8 9PB
Tel: +44 (01539) 822 322
Fax: +44 (01539) 821 399
www.kentmere.co.uk
*Manufacturers of specialty black-and-
white printing papers, including
Kentona, Document Art, Art Classic.*

Kodak Ltd.
Kodak House, Station Road, Hemel
Hempstead, Herts HP1 1JU
Tel: +44 (01442) 261 122
www.kodak.co.uk
*Manufacturers of black-and-white
printing paper, E6 color dyes, and
selenium toner.*

Rayco Chemical Co.
199 King Street, Hoyland,
Barnsley S74 9LJ
Tel: +44 (01226) 744 594
*Suppliers of chemicals for toning and
ready-made toners.*

Shesto Ltd
Unit 2, Sapcote Trading Centre,
374 High Road, Willesdon,
London NW10 2DH
Tel: +44 (020) 8451 6188
Fax: +44 (020) 8451 5450
www.shesto.co.uk
*Suppliers of Badger airbrushes and
compressors.*

Silverprint
12 Valentine Place,
London SE1 8QH
Tel: +44 (020) 7620 0844
Fax: +44 (020) 7620 0129
www.silverprint.co.uk
*Suppliers of chemicals, toners, and
specialty papers.*

Speedibrews
54 Lovelace Drive, Pyrford,
Woking, Surrey GU22 8QY
Tel: +44 (01932) 346 942
www.speedibrews.free-online.co.uk
*Manufacturers of Speedibrews
chemicals including porcelain blue
and FSA toners. All Speedibrews
materials can be bought directly from
Calumet.*

Tetenal Ltd
Tetenal House, Centurion Way,
Meridian Industrial Estate,
Leicester LE3 2WH
Tel: +44 (0116) 263 0306
Fax: +44 (0116) 263 0087
www.tetenal.com
*Manufacturers of a wide range of
toners.*

AUSTRALIA

Fotospeed Australia PTY
32 Commercial Road, Fortitude
Valley, Brisbane QLD, 4006
Tel: +61 (7) 3252 4466
Fax: +61 (7) 3252 4771
www.fotospeed.com.au

Ilford Australia
P.O. Box 144, Mt. Waverley,
Victoria 3149
Tel: +61 (03) 9541 4511
www.ilford.com